D0480263

ART DECO **FASHION**

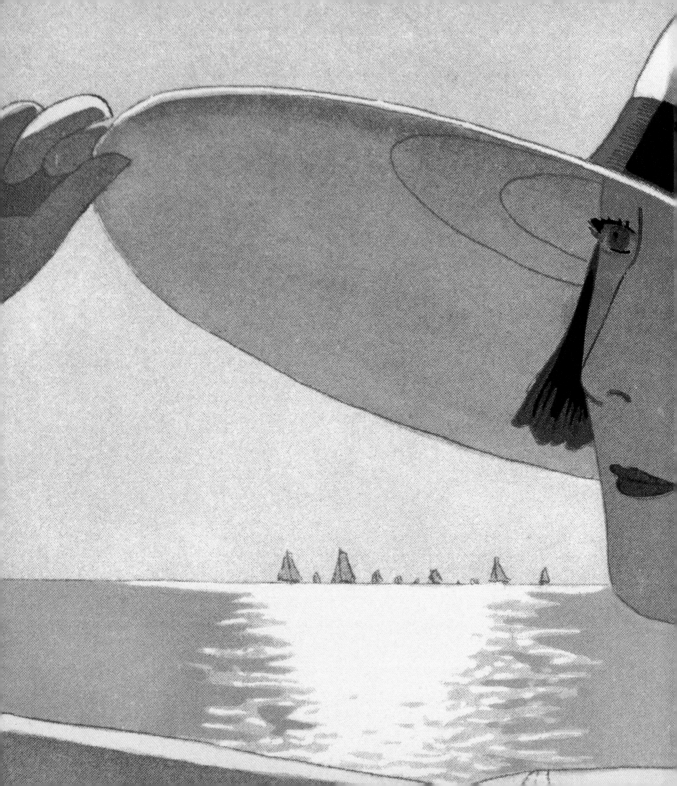

ART DECO FASHION

SUZANNE LUSSIER

V&A PUBLICATIONS

First published by V&A Publications, 2003
V&A Publications
160 Brompton Road
London SW3 1HW

Suzanne Lussier asserts her moral right to be identified as
the author of this book

Designed by Broadbase
Photography by Sara Hodges and Richard Davis of the
V&A Photographic Studio

ISBN 1 85177 3908

A catalogue record for this book is available from the
British Library

The author would like to thank Valerie Mendes and the
Bibliothèque du Musée de la Mode de la Ville de Paris.

Front jacket illustration: *Sortilèges De Beer. La Gazette
du bon ton,* no. 9, 1922, plate 66. NAL.

Back jacket illustration: *La glace ou Un coup d'œil en
passant.* Evening coat by Paul Poiret. Illustration by André
Marty. *La Gazette du bon ton,* no. 6, 1922, plate 47. NAL.

Half-title page: Eduardo Benito, *La dernière lettre persane.*
See plate 84.

Title page: *Sur la digue,* hat by Marthe Collot. See plate 68.

Contents page: Photograph of four women sitting on a boat
(detail), 1928. See plate 67.

Printed in Singapore

V&A Publications
160 Brompton Road
London SW3 1HW
www.vam.ac.uk

CONTENTS

INTRODUCTION

••

'The Ballets Russes…[and] Léon Bakst give an exotic touch to the dresses of the Parisians, displaying slightly Cubist motifs in which feature fragments of broken mirrors and huge sequins, all of which recall the oriental bazaars.' This comment from the March 1924 issue of the Paris fashion magazine *Art, Goût, Beauté* sums up in a few words the fashion of the 1920s: a unique combination of exoticism and modernity, which was at the core of the Art Deco movement.

The term Art Deco was employed for the first time in 1968 by the author Bevis Hillier. It identifies an aesthetic in vogue between 1909 and 1939 which was adopted in architecture, the decorative arts, textiles and fashion; it also influenced the fine arts, film and photography. Art Deco displayed stylized motifs and shapes borrowed from national traditions, folk art and ancient cultures, and was strongly influenced by the art of the avant-garde.

Art Deco emerged from a unique artistic conjunction. From 1905, avant-garde movements sprung up one after another throughout Europe: the Fauves and Cubists in Paris, the Futurists in Italy, the Constructivists in Russia. Meanwhile the Ballets Russes were founded in Russia by Sergei Diaghilev who, wanting to rejuvenate ballet by introducing exotic themes, sets and costumes, employed artists and musicians from the international avant-garde. Too unconventional for the conservative Russian public, the Ballets Russes moved to an ecstatic reception in Paris in 1909, a moment which historians mark as the catalyst of the Art Deco period.

Pivotal in the development of Art Deco, the Ballets Russes imbued fashion with its colourful and voluptuous aesthetic through the genius of fashion designer Paul Poiret; its influence in fashion would be felt well into the 1920s. Diaghilev's dance company would trigger a long-lasting vogue for exoticism in dress and the use of luxurious materials, a vogue strengthened by the arrival in Paris of Russian *émigrés* like Natalia Goncharova, and the discovery of Tutankhamun's tomb.

1 RIGHT
Autoportrait. Tamara de Lempicka, 1929.
Private Collection. © ADAGP, Paris and DACS, London 2002.

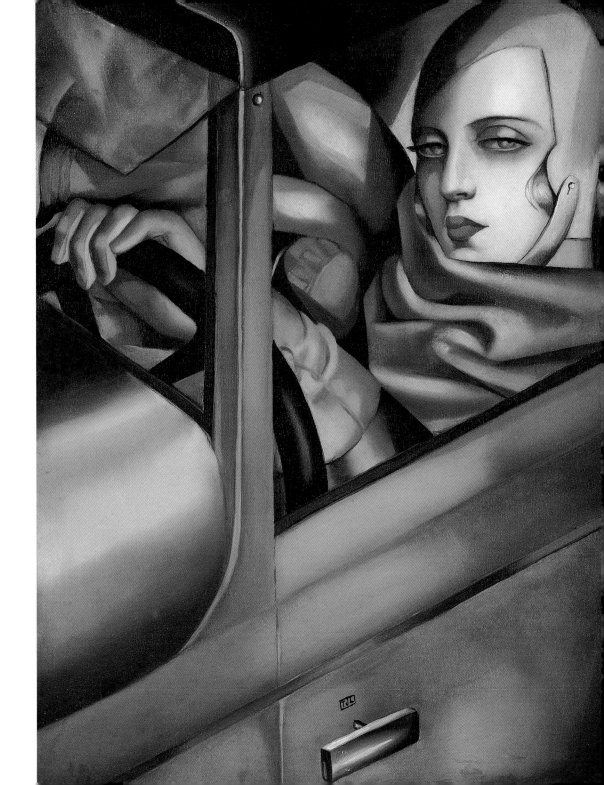

This period was characterized by a unique collaboration between artists of the avant-garde and fashion designers, who imbued fashion with their respective skills and visions. The avant-garde saw in fashion a new and exciting canvas on which to express their ideas; ballet, theatre, fashion illustration and cinema also offered arenas for artistic expression which, ultimately, would influence mainstream fashion.

The emancipation of women and the general liberalism that prevailed in the 1920s were central to the development of the Art Deco style. The growing popularity of sports such as tennis and swimming generated a new and simpler look, which became an ideal ground for experimentation in design and cut. With freedom of movement a priority, designers such as Jean Patou, Madeleine Vionnet and Gabrielle Chanel created the first real style for the modern woman. Although there was a lively fashion industry in Britain and the US, Paris remained the fashion capital of the world, and less famous but significant designers such as Lucien Lelong, Drecoll, Doucet, Molyneux and Worth all contributed to its pre-eminence during the 1920s.

The study of 1920s fashion demonstrates how closely its development was linked to that of Art Deco; it explains how the arts and dress nourished each other, one acting as an inspiration, the other as a medium. It also depicts the complexity and diversity of 1920s fashion, which amounted to so much more than the proverbial flapper's dress and the cloche hat.

PAUL POIRET

The first fashion designer to embrace the ethos of Art Deco was Paul Poiret. His artistic flair, coupled with his remarkable and highly individual cutting skills, enabled him to translate the spirit of the period into revolutionary garments. The sources of his inspiration were innumerable, ranging from Western historical styles to folk traditions, and from avant-garde art to ancient cultures. But it was his interest in the simplicity of Eastern garments that ultimately led him to establish the foundations of modern fashion.

In 1908, when modernized Directoire furniture was all the rage in Paris, Poiret designed a collection of dresses inspired by the *élégantes* of the First Empire. These high-waisted, straight dresses triggered a revolution in fashion: not only did they appear to liberate women from the secular tyranny of the corset, but they also marked a harmonious passage

2 RIGHT
Les robes de Paul Poiret, racontées par Paul Iribe, plate 4. Pochoir colour print. French, 1908.
NAL.

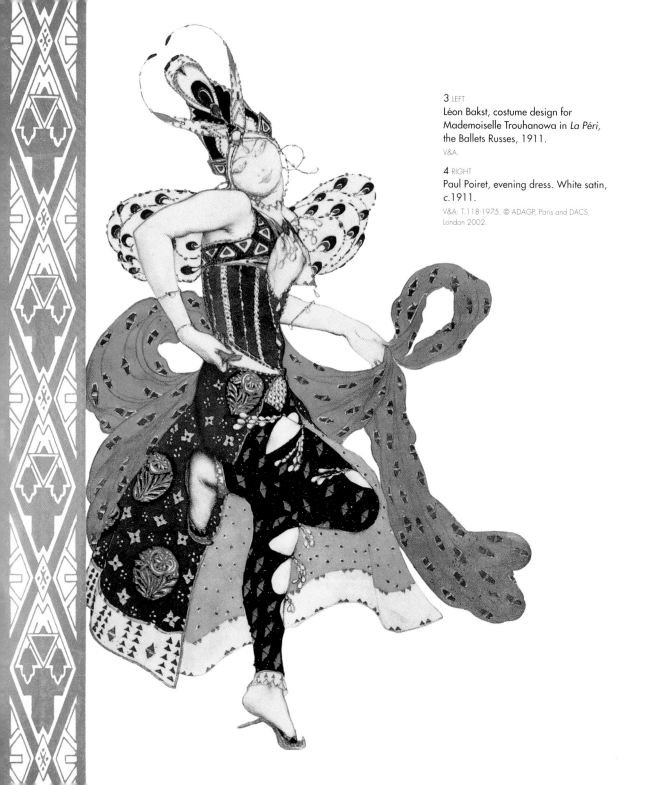

3 LEFT
Léon Bakst, costume design for
Mademoiselle Trouhanowa in *La Péri,*
the Ballets Russes, 1911.
V&A.

4 RIGHT
Paul Poiret, evening dress. White satin,
c.1911.
V&A: T.118-1975. © ADAGP, Paris and DACS,
London 2002.

towards the straighter silhouettes of the coming decade. The Directoire dresses encapsulated the spirit of early Art Deco: his designs displayed bright, acidic hues and used strong juxtapositions of motifs, details and ornaments derived from folk art or combining stylized floral devices and geometric lines. This first major collection was immortalized by Paul Iribe in the album *Les robes de Paul Poiret* (1908). Its daring design and Japanese look launched a new style in fashion illustration.

One year later, the Ballets Russes hit Paris like a storm. The public was overwhelmed by Léon Bakst's Oriental costumes and sets. His colourful and voluptuous aesthetic would open up new avenues of exploration for the artists and designers of the Art Deco movement, and for Paul Poiret in particular. It inspired him to create the 'sultan' style, loosely derived from Oriental dress, which featured garments of an amazing modernity: wide pantaloons gathered at the ankle, and worn under a short or long dress, and ample evening mantles and turbans, cut in luxurious and exotic fabrics. An astute businessman, Poiret organized dream-like, Oriental garden parties at which his guests would parade his latest creations.

Throughout the life of the company, the Ballets Russes commissioned avant-garde artists to design sets and costumes that bore all the hallmarks of the Art Deco movement. Their impact on the wider world of the arts, and especially on fashion, was instrumental in pointing the way to more comfortable and colourful clothes.

Experimentation with Eastern cutting techniques led Poiret away from the heavily ornate dresses of Art Nouveau to the linearity of Art Deco fashion. A white satin dress, made for Madame Poiret for their visit to Berlin in 1911, proved even more revolutionary than the Directoire dresses. Consisting of a pure, simple rectangle of white satin, it was the avant-garde prototype of the chemise-dress of the 1920s, making its first appearance ten years before its time.

A yellow and black wool mantle designed in 1913 illustrates how Poiret was able to combine with rare harmony the bold colours of Fauvism, the vision of Cubism and the exoticism of Eastern garments. Based on a deconstructed kimono, the mantle is made of two rectangles folded on the shoulders and joined on one side with a stylized bow.

Continuing his collaboration with artists of the avant-garde, in 1911 Poiret commissioned Georges Lepape to illustrate a second album featuring his latest collection, *Les choses de Paul Poiret vues par Georges Lepape*, pictured in a very 'Ballets Russes' scenario.

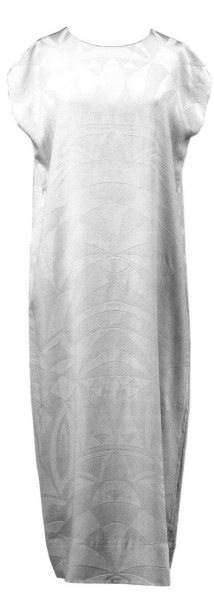

In 1911 Poiret toured Eastern Europe with his models and tailor. He visited the Wiener Werkstätte's fashion department in Vienna, where he purchased large quantities of their colourful fabrics. A strong believer in decorative art, Poiret was struck by the principles of the movement, by which artists, architects and textiles designers worked together to create a harmonious living environment. The Wiener Werkstätte aesthetic, based on the stylization of traditional motifs, was applied to furniture, textiles, wallpaper and fashion. At this point, Poiret began a long relationship with the Wiener Werkstätte and used their fabrics until the end of his career.

On his return to Paris, he created the Atelier Martine, employing untrained working-class girls to create naïve, stylized motifs in bold colours. The designs were sold as wallpapers, textiles and curtains. He also launched the first perfume and make-up shop, a gallery, and a printing workshop, where he employed the painter Raoul Dufy to design prints for him.

Poiret was at the centre of fashion and social life when war broke out in 1914. After this interruption to his career, he never again worked on the same grandiose scale. Accused of too much theatricality, Poiret would be slowly deserted by his clientèle, now attracted to a newer and simpler modernity.

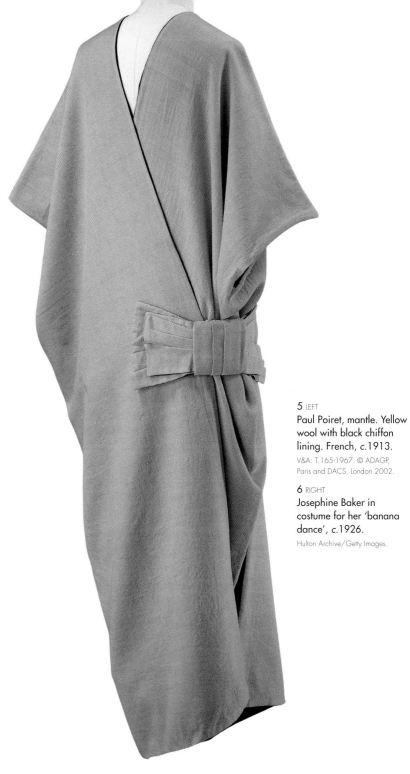

5 LEFT
Paul Poiret, mantle. Yellow wool with black chiffon lining. French, c.1913.
V&A: T.165-1967. © ADAGP, Paris and DACS, London 2002.

6 RIGHT
Josephine Baker in costume for her 'banana dance', c.1926.
Hulton Archive/Getty Images.

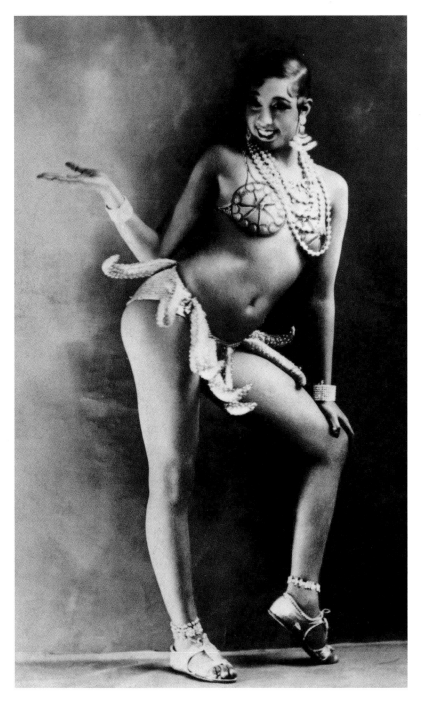

THE 1920s

The end of the War was marked by a wave of exuberance and euphoria which lasted until the stock market Crash of 1929. In Paris, new bars, dance halls and restaurants were opening up on a daily basis. Pleasure-seekers mingled with the artists and writers of the day and the new cosmopolitan elite. Fashion became a way of life, and suddenly meant much more than the latest dress: it encompassed the latest dance, a foreign accent, a glamorous destination, a banned book. After the atrocities of the War, the general impulse was to seek out the exotic, and adopt the modernity of contemporary urban life.

In the factories and at home, women had already begun to play a more active part in life, adopting many traditionally male roles and habits. They worked, they drove cars and piloted aeroplanes, they smoked and drank. During the War, clothes had become more practical: corsets were discarded, skirts were shortened and widened, hair and hats were worn closer to the head. The modern woman, product of the War, would initiate a gender crisis in 1920s fashion, in which Cubist and androgynous looks would co-exist with romantic and more conservative styles.

LANVIN AND THE PICTURE DRESS

Clearly a continuation of the 1916 'war crinoline' – a high-waisted dress with a wide, sometimes hooped skirt – the 1920s 'picture dress' retained the same romantic silhouette, harking back to an idealized past. While dress shapes were becoming straighter, the picture dress displayed a long, wide 'infanta' skirt attached to a fitted bodice, usually at a natural waistline. Jeanne Lanvin would champion this look in pastel tones, first for her daughter, then for debutantes and older women who favoured this more feminine alternative.

The picture dress was designed mainly for formal occasions such as weddings, garden parties and graduation balls. Poiret, however, used it as the basis for a very modern day dress, which combined the outlines of the picture dress with a straight underskirt, made of stiffer fabrics and modern prints. Some women remained faithful to the picture dress well into the 1920s, by shortening the length and dropping the waist.

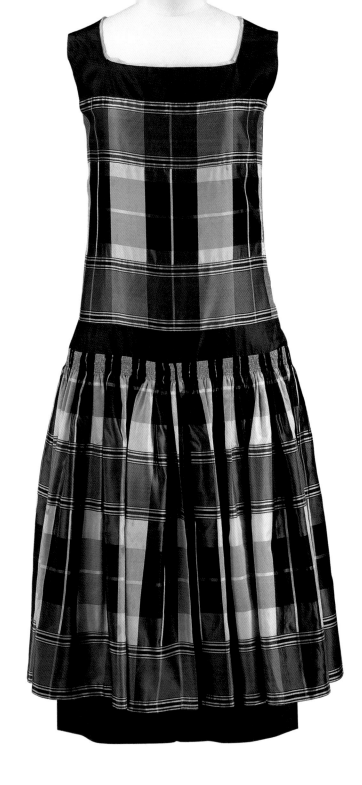

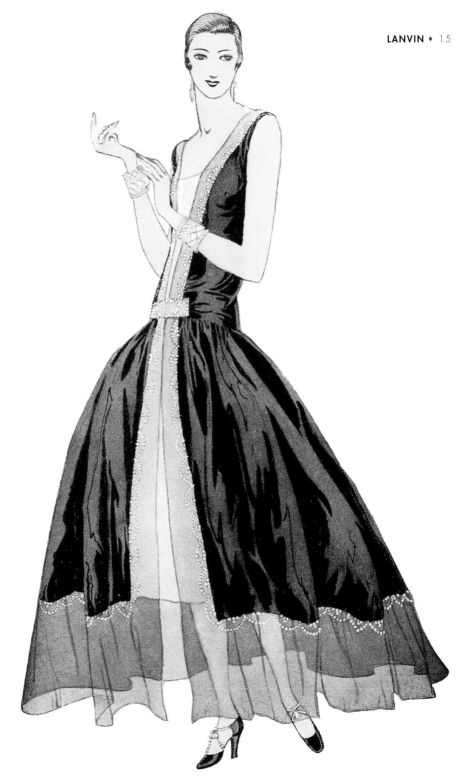

7 LEFT
Paul Poiret, day dress. Silk tartan.
French, 1926.
V&A: T.342-1974. © ADAGP, Paris and DACS,
London 2002.

8 RIGHT
Jeanne Lanvin, picture dress.
British *Vogue*, February 1926.
NAL.

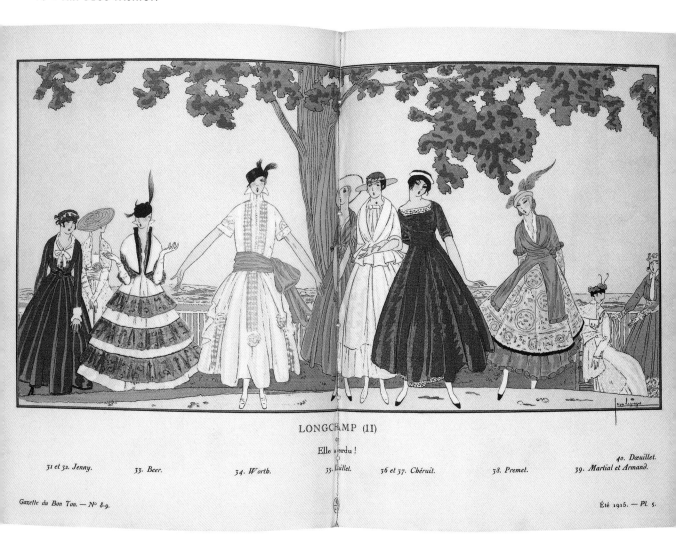

LONGCHAMP (II)
ou
Elle a perdu !

31 et 32. Jenny. 33. Beer. 34. Worth. 35. Paillet. 36 et 37. Chéruit. 38. Premet. 40. Dœuillet.
39. Martial et Armand.

Gazette du Bon Ton. — No 8-9. Été 1915. — Pl. 5.

LANVIN
P A R I S

9 ABOVE
Longchamp (II). La Gazette du bon ton,
nos. 8–9, summer 1915, plate 5.
NAL.

10 LEFT
Emblem of the House of Lanvin. *La femme*
et l'enfant: Patrimoine Lanvin.

11 RIGHT
Boué Sœurs. Photo Seeberger, no. 129,
25 June 1926.
Bibliothèque nationale de France.

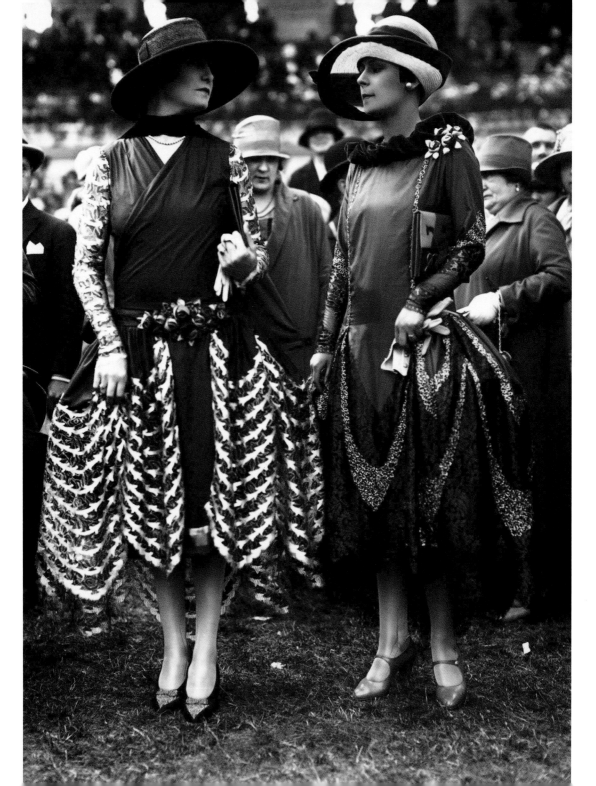

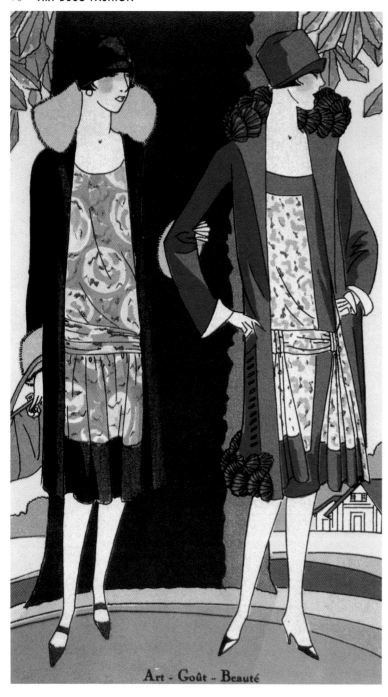

Art - Goût - Beauté

DAYWEAR

By the beginning of the 1920s, the Eastern dress shapes explored by Poiret had evolved into straight and flat dresses. Under these sheath-like garments, the female body became almost abstract and the natural waist was consigned to the past. Throughout the whole decade, the focus would remain on the hips, which were swathed with sashes, covered with exotic embroideries or emphasized by hip-length jackets.

Flat and straight dresses provided an ideal canvas for the artistic motifs of the period: embroideries, appliqués and stylized, naturalistic or geometrically patterned prints. The sudden importance of prints spawned the idea, supported by both the avant-garde and fashion designers, of creating designs to suit the shapes of the garments. This concept, inspired by Japanese kimonos, would produce the most beautiful Art Deco dresses.

12 LEFT
Illustration, 1925, from *Art, Goût, Beauté*. From *The Golden Age of Style* by Julian Robinson (Orbis Publishing, London, 1976), p. 94.
NAL

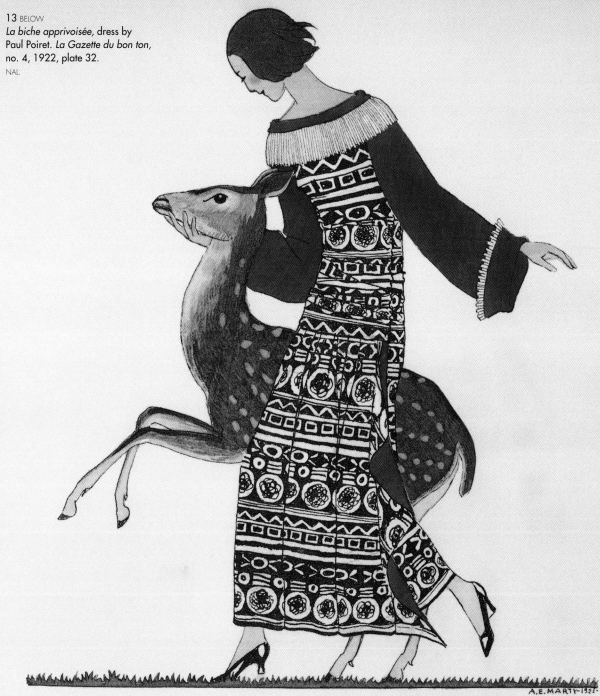

13 BELOW
La biche apprivoisée, dress by
Paul Poiret. *La Gazette du bon ton*,
no. 4, 1922, plate 32.
NAL.

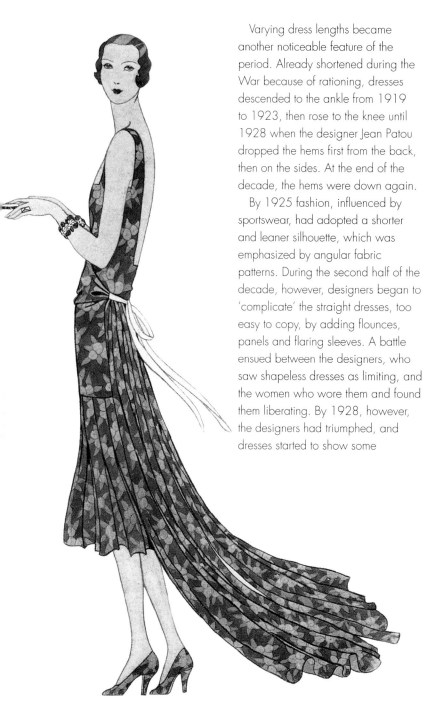

Varying dress lengths became another noticeable feature of the period. Already shortened during the War because of rationing, dresses descended to the ankle from 1919 to 1923, then rose to the knee until 1928 when the designer Jean Patou dropped the hems first from the back, then on the sides. At the end of the decade, the hems were down again.

By 1925 fashion, influenced by sportswear, had adopted a shorter and leaner silhouette, which was emphasized by angular fabric patterns. During the second half of the decade, however, designers began to 'complicate' the straight dresses, too easy to copy, by adding flounces, panels and flaring sleeves. A battle ensued between the designers, who saw shapeless dresses as limiting, and the women who wore them and found them liberating. By 1928, however, the designers had triumphed, and dresses started to show some sculptural features again. The waist returned to its normal place, underlined by narrow belts. Skirts, tight on the hips and thighs, flared slightly from the knees.

A more urban lifestyle demanded comfortable and practical fabrics, such as jersey, mohair, gabardine, alpaca, kasha – a soft, silky fabric made of wool mixed with goat's hair – and the new rayon. Ornamentation disappeared in favour of pockets, buttons, belts and double seams, all borrowed from men's clothing. Once deemed suitable only for mourning, or for the working-class, black became fashionable and could be worn at any time of day.

Costume jewellery was popularized by Chanel in 1924 to complement the very straight and simple suits and dresses. Brooches, buckles and clips inspired by Cubist and African art were worn on lapels, shoes, hats and collars.

14 LEFT
Volants et fronces. French *Vogue*, April 1929, p. 23.
NAL.

15 RIGHT
Day dress. Printed chiffon. La Samaritaine, 1929.
V&A: T.171-1964.

16 FAR RIGHT
Auteuil grand steeple-chase. Photo Seeberger, 17 June 1928.
Bibliothèque nationale de France.

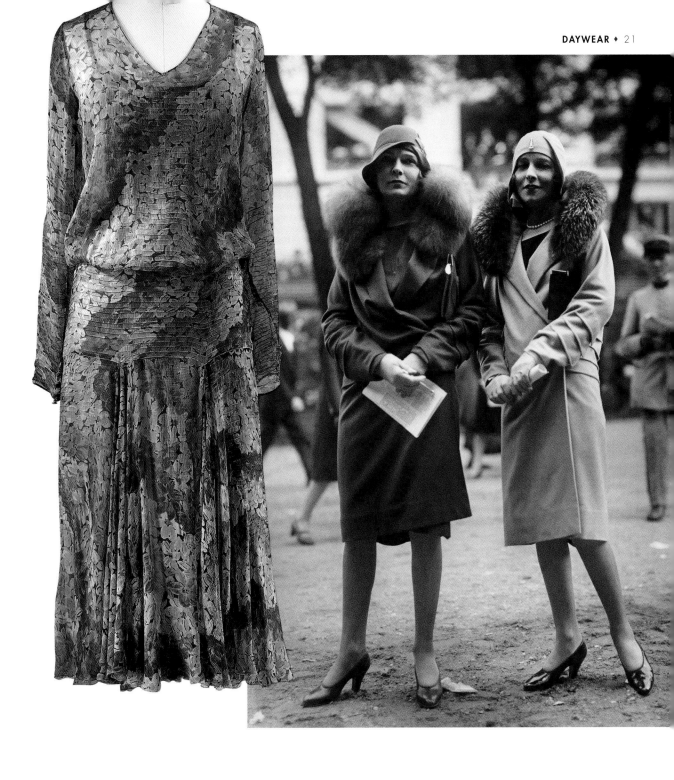

EXOTICISM

The 1920s saw the triumph of exoticism. Art Deco drew its inspiration from many sources: the mythical Orientalism of the Ballets Russes, animals and flowers from China and Japan, Ancient Egyptian imagery, African art and traditional Russian motifs.

The influence of Japan can be seen in the work of all the major designers of the period, who explored the cut of the kimono and its motifs. Often associated with mystery and luxury, Chinese motifs were used for evening fashion, printed on elegant silk pyjamas, or embroidered on expensive dance dresses. Daywear ensembles made of Chinese printed silks were designed by the ever-exotic Liberty & Co. in the mid-1920s. African and Egyptian motifs, more stylized, were often used for exclusive garments designed by the avant-garde, as seen, for instance, on a sumptuous evening cape embroidered with African-inspired motifs by the House of Myrbor.

17 ABOVE
Myrbor, coat. White wool embroidered with gold thread. French, *c.*1925.
V&A: T.221-1967.

18 RIGHT
Les tissus d'art. Photo Seeberger, no. 63, 22 June 1923.
Bibliothèque nationale de France.

19 FAR RIGHT
Jacket. Hand-beaded lurex, square-shaped with round neckline and Egyptian-style motifs. Probably French, *c.*1922–9.
V&A: T.91-1999.

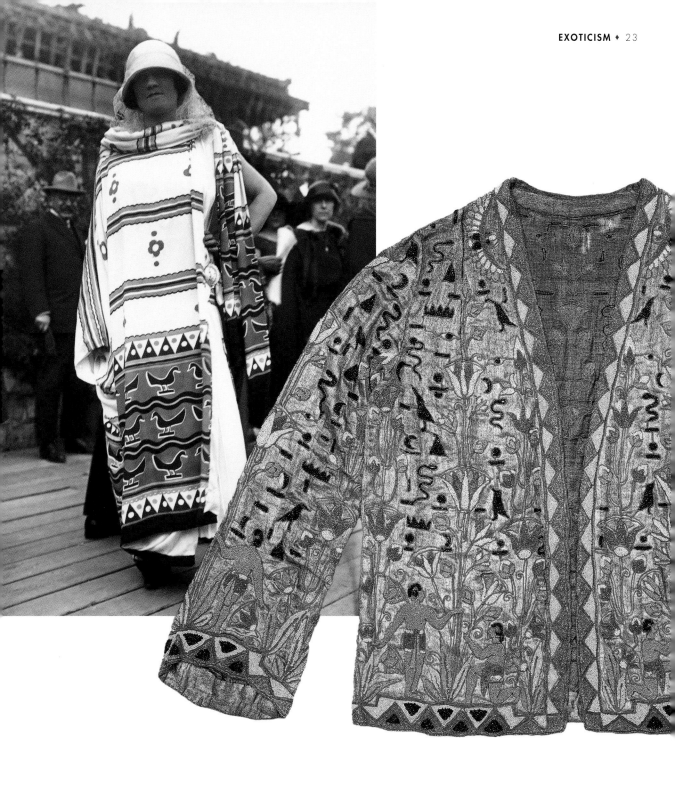

The most significant foreign influence on 1920s Western fashion came with the arrival in Paris of 150,000 Russians, fleeing the Bolshevik Revolution. Because they had learned embroidery and sewing in their childhood, almost half of the women ended up working for major couture houses. Traditional Russian embroideries became extremely popular as a post-war substitute for elegant fabrics. The foremost house for embroidery was the House of Kitmir, owned by the Grand Duchess Maria Romanova, which adorned Chanel's dresses with designs that were Persian, Chinese and Ancient Egyptian in origin.

Some Russian *émigrés* opened their own fashion houses, introducing elements of traditional Russian dress to Europe. Fashion magazines were soon inundated with designs '*à la russe*', '*à la boyard*', '*à la caucasienne*'. Even though it was rooted in nostalgia, this historical style infused Western fashion with a new dynamism.

20 RIGHT
La Gazette du bon ton, no. 2, 1922, sketch XII.
NAL.

21 FAR RIGHT
Adieu! Evening coat by Worth. *La Gazette du bon ton*, no. 4, 1921, plate 28.
NAL.

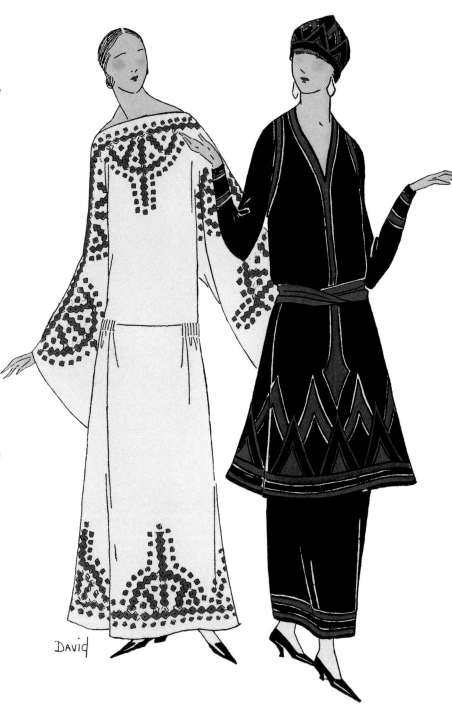

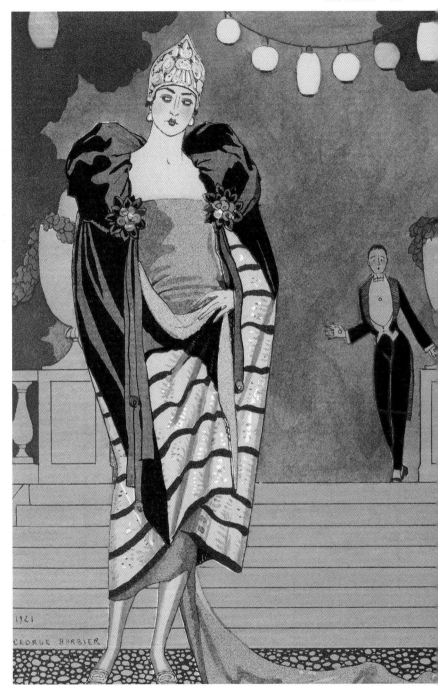

The Russians also promoted their traditional combination of fabric and fur, still new to Western fashion. Embroidered dresses, blouses and evening coats lined and trimmed with fur, or decorated with froggings, became classics of the 1920s. In addition, a new silhouette was launched, derived from a Russian peasant costume in which an embroidered men's tunic (*kosovorotka*) was worn over a longer skirt. The most popular feature of Russian national costume was probably the northern Russian *kokoshnik*, a festive headdress that influenced tiara design and came to epitomize, with the cloche, the hats of the 1920s.

By 1925, the style had changed, and fanciful, exotic elements were discarded. Russian folk art was no longer in vogue and had to give way to sportswear and new, more sober, Cubist styles.

EVENING WEAR

••

Night-life became the focus for post-war exuberance and gave birth to the most glamorous evening fashion of the new century. Throughout the 1920s, and in spite of the changing fashions, the legacy of the Ballets Russes remained evident in the exoticism and luxury of the evening gowns and mantles, especially in the continuing use of shiny fabrics, sashes and tassels.

Early 1920s evening dresses were sleeveless, long and feminine, gathered on the hip or the back, and embellished with exotic embroideries. By 1925, evening dresses were designed to reflect the frenzy of the newly discovered charleston and jazz dancing. Short and square gowns held on the shoulders by narrow straps, and slit on the sides, were made of shiny silks, light velvets or lamés, embroidered with sequins, pearls, or metallic threads, to achieve the maximum effect of brilliance.

Feathers, boas, layers and fringes were added to accentuate movement. More daring women wore hand-painted silk pyjamas, with brocade shawls or Indian gowns.

Sleeveless gowns and the vogue for African art triggered a fashion for 'slave' bracelets, often worn high up on the arm. Ankle chains and long strings of cultured pearls complemented the dance-wear.

To cover their bare shoulders and arms, women wrapped themselves in mantles inspired by Japanese dress, trimmed with fur, adorned with tassels, appliqués or exotic embroideries. Evening coats followed the changing silhouette of the decade, ample and unstructured in the early years, closer

22 LEFT
Le pouf, evening dress by Paul Poiret. Illustration by André Marty. *La Gazette du bon ton,* no. 7, 1924, plate 38.
NAL.

23 RIGHT
Voisin, flapper dress. Orange and yellow velvet with gold beading. French, c.1925.
V&A: T.139-1967.

24 FAR RIGHT
Le jugement de Paris. Plate 3, *Falbalas & Fanfreluches: almanach des modes présentes, passées et futures* by Georges Barbier. French, 1924.
NAL.

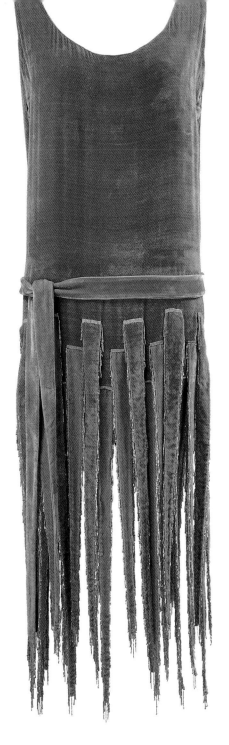

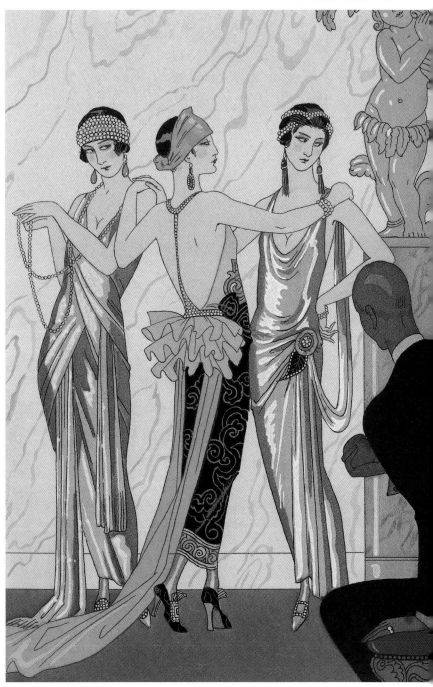

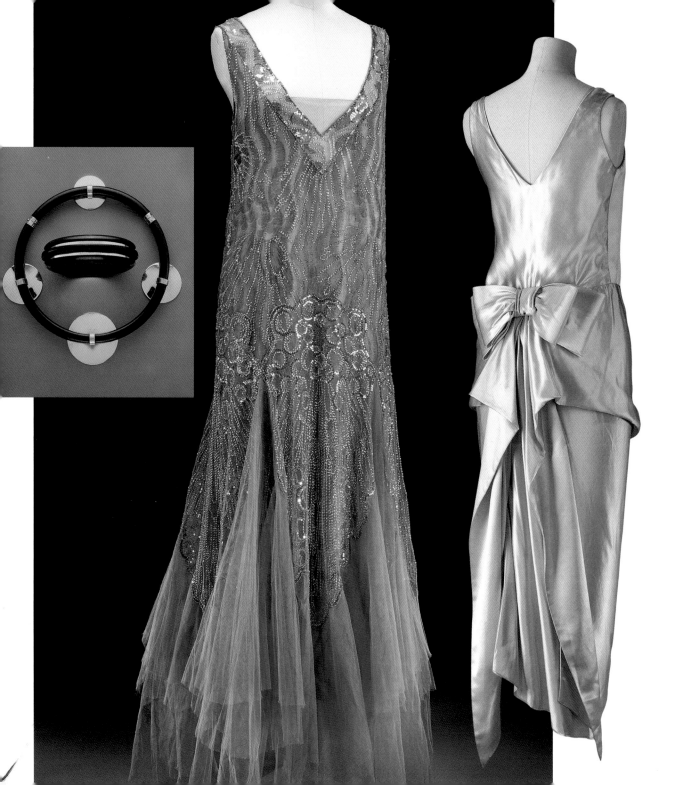

to the body by the mid-1920s, and flaring out by the end of the decade. They displayed long collars, worn on the shoulders, or big padded collars known as 'boule'. With the arrival of tango fever came large shawls of hand-painted silk, embroidered brocade or paisley, which covered the shoulders with their exotic motifs and long fringes.

The popularity of exotic fabrics inspired the lacquer artist Jean Dunand to create a range of fabrics patterned with eggshell and diluted lacquer applied with an atomizer on crêpe de Chine, shantung, Indian silk and silk velvet. Exclusive designs were sold to Jeanne Lanvin or Madame Agnès. They were also manufactured for export by Rodier and Ducharne.

25 FAR LEFT
Jean Fouquet, necklace and bracelet. Ebony, chrome-plated metal and gold. French, 1931.
Private Collection, New York.
© ADAGP, Paris and DACS, London 2002.

26 CENTRE LEFT
Evening dress. Aquamarine and gold chiffon with iridescent sequins. French, c.1928–9.
V&A: T.56-1961.

27 LEFT
Evening dress. Cream satin. USA, c.1919.
V&A: T.172-1967.

28 RIGHT
Beaded dance dress (detail). French, 1925.
V&A: Circ.14-1969.

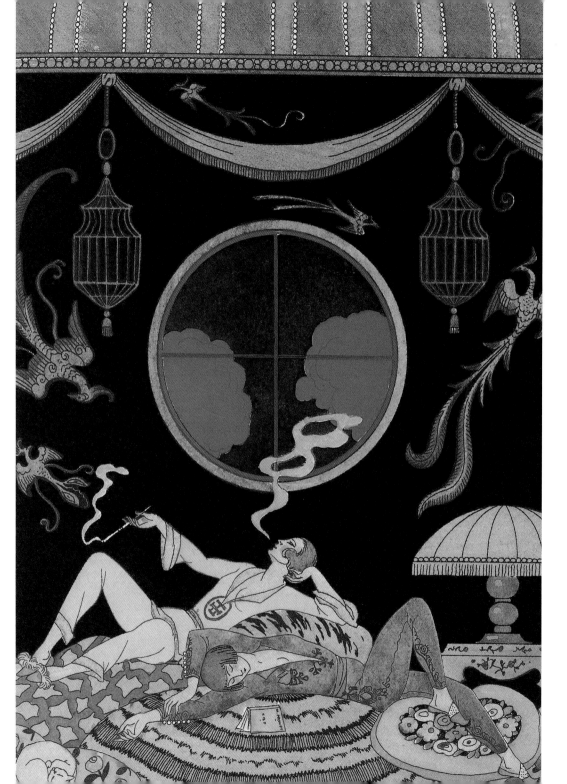

30 LEFT
Itylus, evening coat. Black
velvet with purple feather collar.
Italian, 1924–26.
V&A: T.3-1979.

31 BELOW
Cover for *Art, Goût, Beauté:
feuillets d'élégance féminine,*
no. 53, January 1925.
NAL.

29 OPPOSITE
La paresse. Plate 7, *Falbalas & Fanfreluches:
almanach des modes présentes, passées et
futures* by Georges Barbier. French, 1925.
NAL.

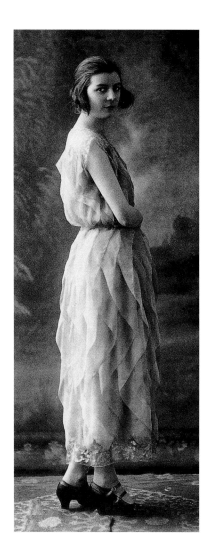

VIONNET

••••••••••••••••••••••••••••••••

The 1920s saw the triumph of two women in haute couture, Madeleine Vionnet and Gabrielle Chanel. In their own different ways, they both launched a new style for the modern woman, Vionnet with a cut, Chanel with a style. Freedom and movement were pivotal to their designs.

Passionate about classical dress, Vionnet exploited its simplicity and the potential of its drape. She also investigated the possibilities offered by Japanese dress and the art of origami. In the early 1920s, she tried to cut a whole dress in the bias of the fabric, a technique until then only used for collars and flounces. Not only did the dress fit better, but it also fitted differently. Bias-cut dresses soon became her trademark.

Draping directly on a half-scale mannequin, Vionnet experimented intensively with the fabrics, often letting them dictate the shape or the effect. Her designs were based on a rigid geometry, using the square, the circle and the triangle, and on organic structures, such as the petals of a flower or a pine cone. Needless to say, she used motifs and embroideries very cautiously, preferring the effect obtained by the fabric alone. For her

rare, yet stunning, embroidered dresses, she commissioned the famous embroiderer Lesage to develop a new technique of embroidering on bias-cut dresses, as well as a method of dyeing in shades.

By 1925, when the straight silhouette began to adopt pleats and godets, designers started to use Vionnet's bias cut, and shorter skirts were now displaying her handkerchief points. During this time she designed her famous blouson dress, tied around the hips into a front bow.

Differing slightly from the current two-dimensional style of the decade, Vionnet's sculptural dresses remained, however, extremely modern and sophisticated. Unlike the work of other fashion designers of the period, her forays into modernity did not borrow features from men's clothing, but instead focused on the curves and forms of the female body.

Often compared to Cubist sculpture, Vionnet's designs were superbly illustrated by the Futurist artist Ernesto Thayaht. Her style would come to full fruition in the 1930s and reign supreme throughout the decade.

32 LEFT
Madeleine Vionnet, dress, summer 1921. From *Vionnet* by Jacqueline Demornex (Editions du Régard, Paris, 1990), p. 178.

33 ABOVE RIGHT
Oui. Plate 3, *Falbalas & Fanfreluches: almanach des modes présentes, passées et futures* by Georges Barbier. French, 1921. NAL.

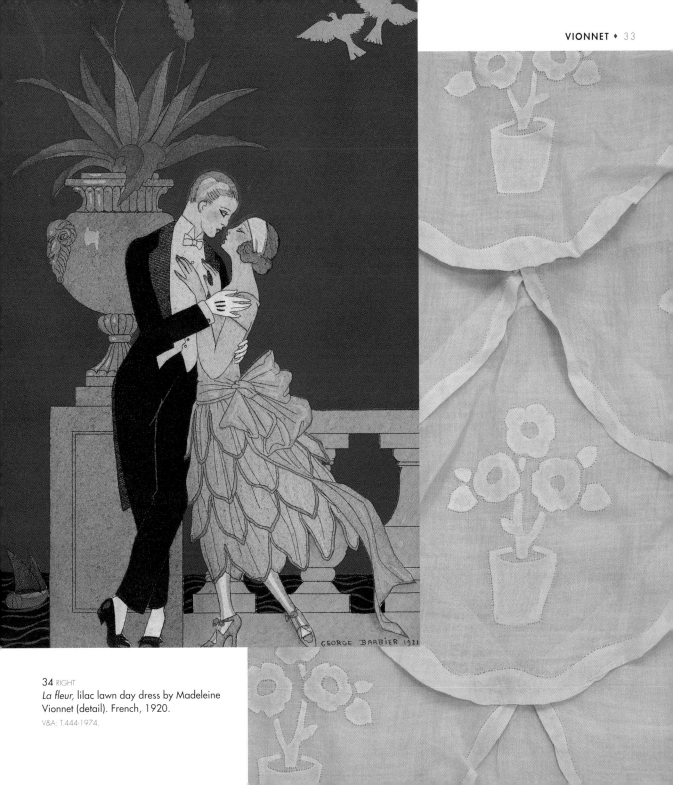

34 RIGHT
La fleur, lilac lawn day dress by Madeleine Vionnet (detail). French, 1920.
V&A: T.444-1974.

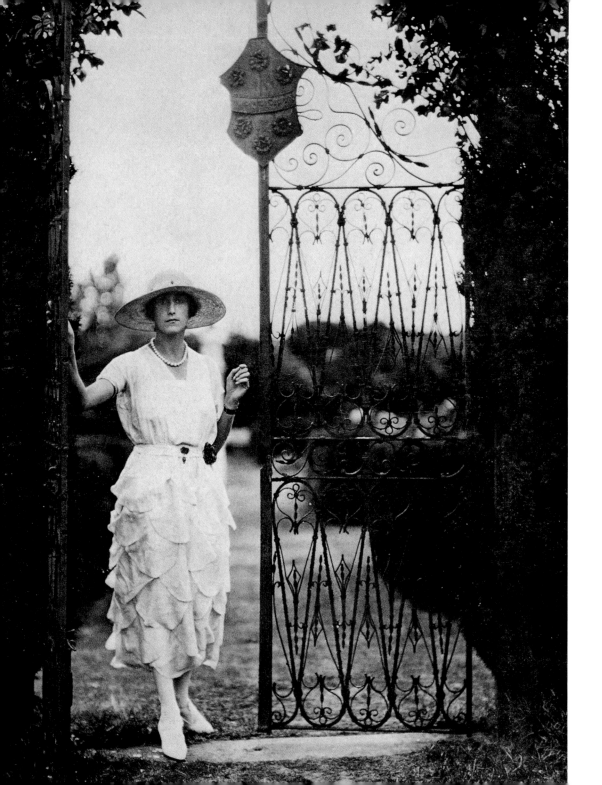

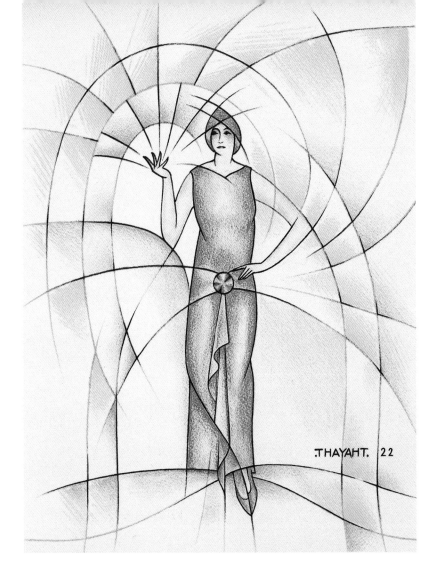

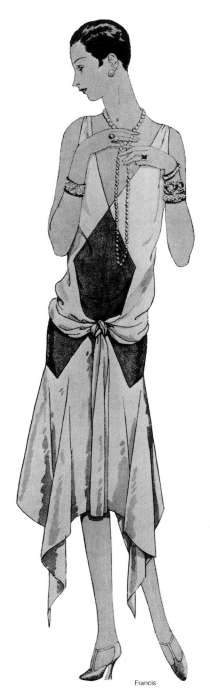

35 LEFT
Sybil, Marchioness of Cholmondeley in her dress by Vionnet, 1920. Plate 4 from *Fashion; An Anthology by Sir Cecil Beaton* by Madeleine Ginsberg (V&A Publications, London, 1971).

36 ABOVE
Thayaht, *Une robe de Madeleine Vionnet. La Gazette du bon ton,* no. 8, vol. 1/2, 1922, plate 62.
NAL.

37 RIGHT
Madeleine Vionnet, dress, 1926. Illustration from *In Vogue: 60 years of fashion and celebrity from British Vogue* by Georgina Howell (Penguin, London, 1978), p. 84.
NAL.

Francis

CHANEL

••••••••••••••••••••••••••••••••••••••

Gabrielle Chanel had been established as a designer in Biarritz and Deauville since the War. Responding to the growing popularity of sports, she set about creating an elegant range of leisurewear suitable for these luxurious seaside resorts.

Although she was not a designer like Vionnet, Chanel nevertheless had an incredible flair for fashion, drawing her ideas from the social circles of her lovers: during her affair with the Grand Duke Dimitri she adapted his traditional Russian clothes into luxuriously embroidered garments for women, and opened a house of embroidery for his sister, called the House of Kitmir. Her association with the Russian *émigrés* of Paris would prove fruitful: through Misia Sert, a great patron of modern art who became her mentor and muse, she was introduced to the artistic avant-garde. Among them were Jean Cocteau and the artists Iliazd and Paul Mansouroff, who designed stunning jerseys for her.

In 1924 Diaghilev asked Chanel to design the costumes for the Ballets Russes' production of *Le Train Bleu*. The story was set in a seaside resort, a milieu she knew well. She dressed the dancers in jersey bathing suits and sportswear, based on her own collection. Chanel also worked on

Cocteau's version of *Antigone*, this time creating stunning hand-knitted coats and dresses with stylized traditional motifs.

Her relationship with the Duke of Westminster provided her with yet more inspiration. The Duke was keen on outdoor life, and Chanel began wearing – with her usual aplomb – blazers, sailor trousers, berets and polo jumpers, which she had copied in silk and wool. Her modern, androgynous style suited this boyish *garçonne* look perfectly. An astute businesswoman, she would not only parade her own creations, but also hire mannequins who looked like her to promote her image.

By the end of the 1920s, Chanel had established the 'basics' of modern fashion: the three-piece suit, designed during the War, comprising a pleated skirt, her trademark belted jumper, and the loosely cut jacket with large pockets. She also popularized the little black dress, the trouser suit, and the unusual combination of daywear and huge pieces of costume jewellery.

38 LEFT
The Ballets Russes' Lydia Sokolova and Léon Woizikovski in *Le Train Bleu,* 1924. Costumes by Chanel.
V&A.

39 RIGHT
Chanel, evening dress. Silk with gold embroidery and crystal bugle beads. French, 1922.
V&A: T.86-1974.

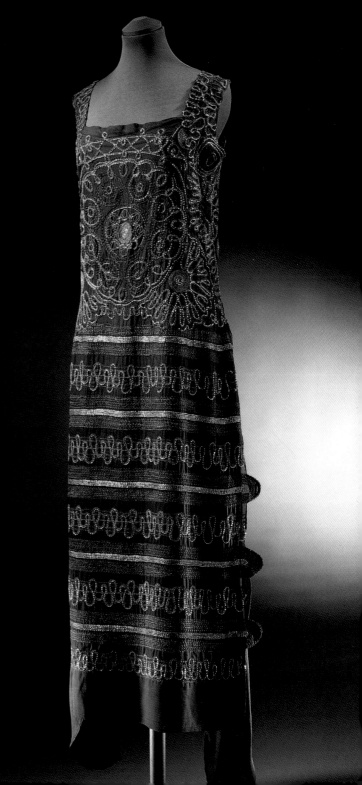

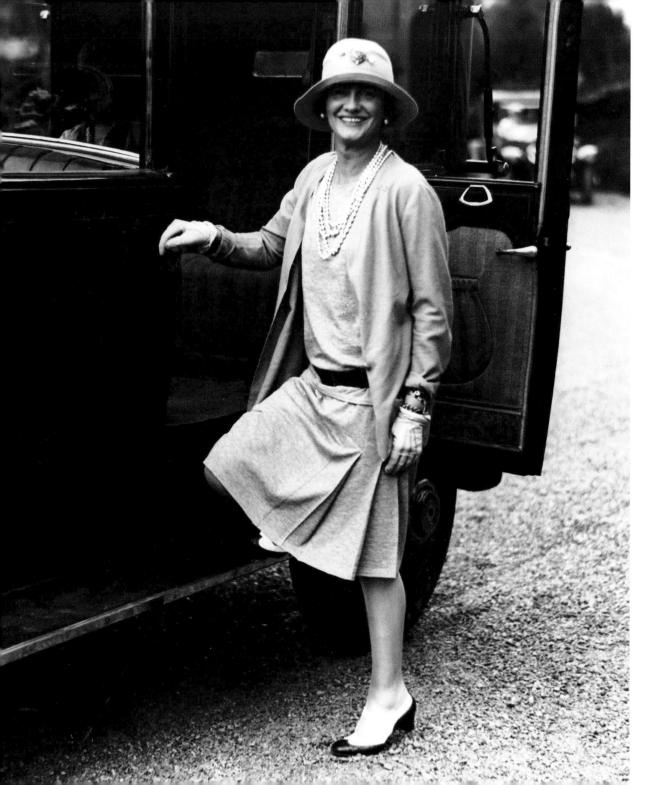

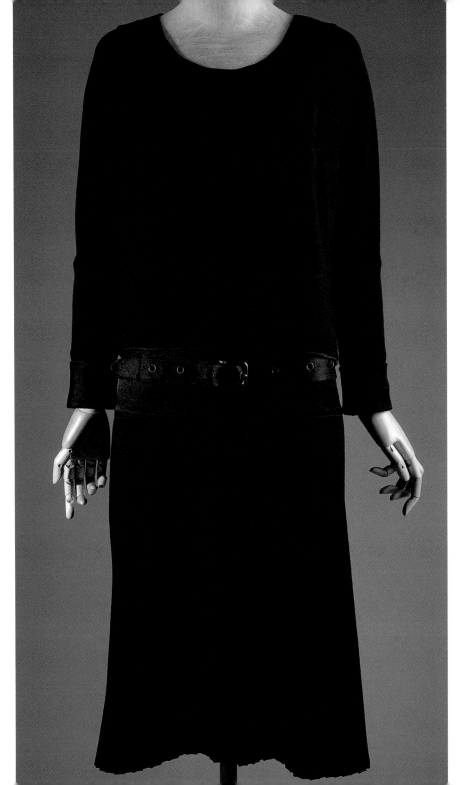

40 FAR LEFT
Chanel wearing costume
jewellery, 1928.
Topham Picturepoint.

41 LEFT
Chanel, day ensemble. Black
wool jersey and silk satin.
French, 1926.
Gift of the New York Historical Society. The
Metropolitan Museum of Art, New York.

FASHION AND THE AVANT-GARDE

From their own countries, or exiled in Paris, the artists of the avant-garde were highly influential in the development of Art Deco fashion. Directly involved in the design of textiles and dress, or providing inspiration and ideas, they imbued contemporary dress with a distinctly modern and decorative identity.

The Wiener Werkstätte

Influenced by the ideas of the English Arts and Crafts Movement, the artists of the Wiener Werkstätte (the 'Vienna Workshops') promoted an all-embracing artistic environment through the synthesis of art and the design of everyday objects. The concept rapidly spread throughout Europe, and the impulse towards the creation of functional objects steered many artists towards dress design.

The Wiener Werkstätte, composed originally of architects and interior designers, opened a fashion department in 1910 where accessories, dresses and pyjamas were designed to reflect the general style of the movement. Avant-garde artists were commissioned to create striking hand-printed fabrics, using unusual colour schemes and bold and colourfully contrasted designs, which featured geometrical shapes, stripes and small stylized flowers. At the end of the 1920s, patterns were applied with stencils and fine spray jets, a technique derived from avant-garde painting. The artists of the Wiener Werkstätte did not innovate in the shapes of their garments, but they attained a consummate level of colour sense that had a strong influence on designers such as Sonia Delaunay and Paul Poiret.

Italy and Russia

In contrast to the Wiener Werkstätte, the Russian and Italian avant-garde based their involvement with fashion on ideology. In aiming to reform the social environment, they designed colourful working clothes which combined creativity, comfort and utility. Freed from the constraints of consumerism, they were able to explore and apply their artistic visions, which turned out to be extremely modern and innovative. Because of their utopian character, however, very few of the garments were actually produced, let alone preserved.

42 RIGHT
Max Snischek. Sketch for a Wiener Werkstätte coat, 1914. Watercolour and pencil on paper. From *Viennese Design and the Wiener Werkstätte* by Jane Kallir (Thames and Hudson, London, 1956), p. 114.

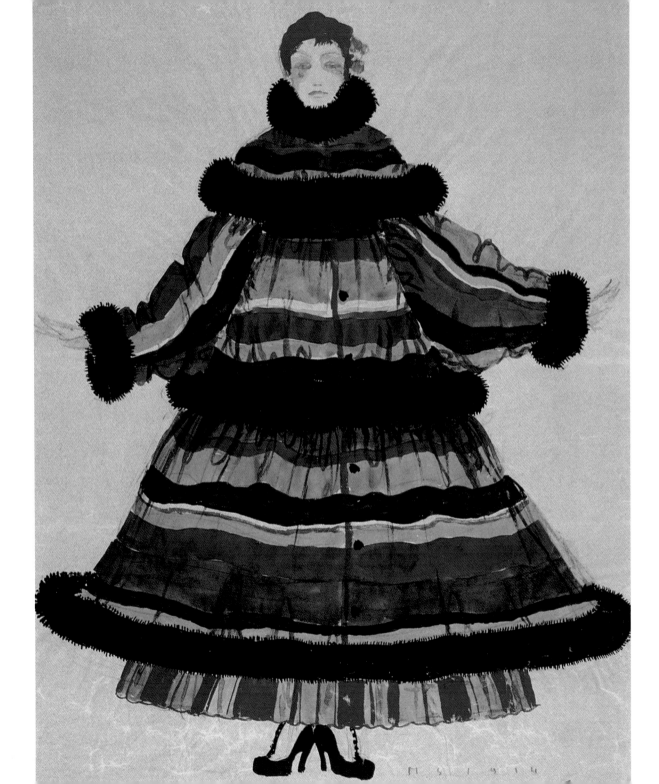

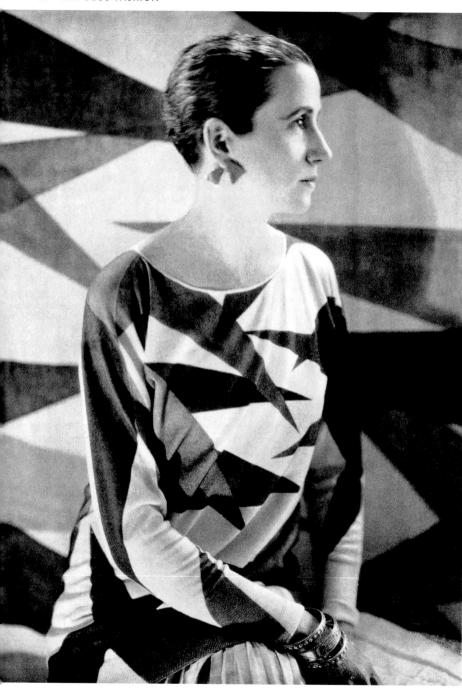

43 LEFT
Edward Steichen, photograph
of Madame Agnès, 1925. From
*In Vogue: 60 years of fashion
and celebrity from British Vogue*
by Georgina Howell (Penguin,
London, 1978), p. 55.
NAL.

44 RIGHT
Fortunato Depero, waistcoat.
Woollen twill. Italian, 1923.
From *Europe 1910–1939: Quand
l'art habillait le vêtement* by
Valerie Guillaume (Palais Galliera,
Paris, 1997), p. 38.
© ADAGP, Paris and DACS, London 2002.

The Italian Futurists

Fascinated by the dynamism of modern life and movement, the Italian Futurists began to design clothes as a reaction against the historical styles of the pre-War period. Designs by Giacomo Balla, dated 1914, show a redefinition of the male suit: the jackets were cut asymmetrically, with no lapels or pockets, and displayed large, contrasting geometrical forms. Beautiful waistcoats, designed by Fortunato Depero, featured rounded forms confronting sharp spears – a recurrent pattern in the movement.

The search for dynamism led Balla to create *'modifiants'*, coloured geometric forms that could be fixed on garments, allowing an infinite variety of looks to suit the mood of the wearer. In 1920, Ernesto Thayaht launched the *'tuta'*, based on the American overall, which epitomized the ideal Futurist dress: made in one piece, practical, and of great simplicity, it was easy to put on, to wear, and required no shirt or tie. One thousand cutting patterns were sold within days, even to the Florentine aristocracy.

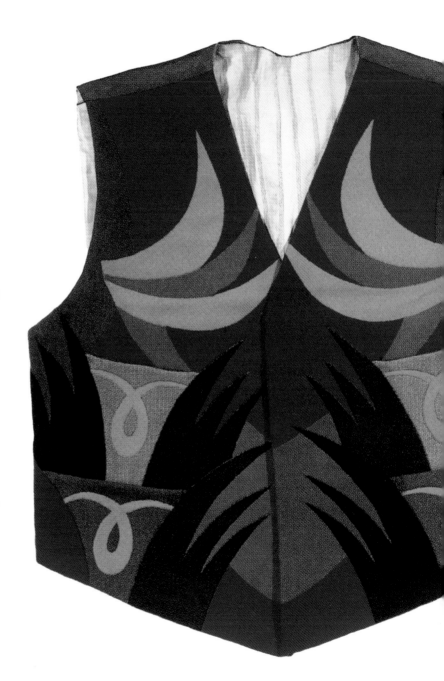

Like the Dadaists, the Futurists worked with unusual fabrics and challenging shapes: ties made of celluloid, wood or metal, asymmetrical shoes, trapezoidal bags, hats with incorporated radio headphones. Their materials and techniques even included phosphorescent materials and body painting, as well as more conventional decorative devices such as embroidery and collages of geometrical and floral forms. In their Manifesto for Women's Futurist Fashion (1920), they advocated the use of paper, glass, aluminium, plants and even live animals.

Like mobile works of art, the Futurists enjoyed parading their clothes in the streets of Florence, in a self-promoting and provocative gesture. Their involvement with fashion was always explained in manifestos, mainly poetic and utopian. The movement became increasingly nationalistic as Fascism and the War hit Italy, and Futurism, which originated in a two-fold desire to 'bring colour and joy' and to shock the establishment, would become the tool of the Fascist government. Back in Italy, having spent four years with Madeleine Vionnet, the Futurist artist Ernesto Thayaht designed a collection of swim-suits ('moda solare'), Futurist hats, and costumes for the theatre. The Futurists' involvement with Fascism eventually became all-consuming, however, and they stopped producing fashion designs on the eve of the Second World War. Nevertheless, their influence on fashion designed by the international avant-garde was immense.

The Russian Constructivists

The Russian avant-garde started designing textiles and dress for the country's elite around 1915; after the Revolution costume became a symbol of new egalitarian values, as well as a powerful tool for social cohesion. The painters Popova, Rodchenko and Stepanova, adherents of the newly formed Constructivist movement, decided to devote their work to the design of the new Russian dress.

Stepanova and Popova worked on the simplification of the dress. The use of boldly coloured geometric patterns, inspired by Cubism and dynamically juxtaposed, would lead them naturally towards simpler cuts. Traditional peasant costumes, made of three rectangles and decorated with stylized embroideries, also inspired them. Another goal was to stress the functionality of the garments by conspicuously underlining the components and structure with bold seams and zips, and by contrasting colours and materials.

Soon, Stepanova and Popova started to design their own fabrics. Based on the straight line and the circle, their designs featured huge graphic elements which would remain unmistakable during movement, and even when the garment was creased.

Following in the steps of the Futurists, Rodchenko explored the concept of the overall, in which he saw the epitome of the working-class dress. For maximum functionality, he designed it with detachable pockets and sleeves. Stepanova applied the concept to sportswear, and added interchangeable coloured elements.

Their work was displayed at the 1925 Exposition Internationale des Arts Décoratifs et Industriels Modernes in Paris, before an amazed audience. However, their lack of experience in the textiles industry forced them to stop designing clothes shortly afterwards.

45 RIGHT
Design for a football kit, 1923. Illustration from *Europe 1910–1939: Quand l'art habillait le vêtement* by Valerie Guillaume (Palais Galliera, Paris, 1997), p. 75.
Archives Rodtchenko & Stepanova, Moscow.

Natalia Goncharova

Natalia Goncharova had a long career with the Ballets Russes, producing astonishing costumes inspired by her Russian heritage and her work with the avant-garde. Like many Russian refugees in Paris, she also designed dresses, which strongly reflected her work for Diaghilev.

Between 1922 and 1926, Natalia worked for the House of Myrbor, owned by the Italian Marie Cuttoli. The wife of a French ambassador, Cuttoli had opened an atelier of embroidery in Algiers before the War. Back in Paris, she launched a new shop, succumbing to the vogue for all things Slav by giving it a Russian name. Myrbor sold dresses embroidered with abstract designs, and rugs and curtains designed by the avant-garde.

Natalia, who had worked for the famous designer Nadejda Lamanova in Moscow, proved to be a remarkable stylist in her own right. Driven by her fascination for abstract patterns, as well as by her reaction against the prevailing fashion for Orientalism, she experimented with distorted, brightly coloured forms, which she assembled with deliberate crudeness. Goncharova's primitive interpretation of Russian folk art and Byzantine mosaics was evident not only in her costumes for the Ballets Russes but also in her designs for Myrbor.

46 RIGHT
Natalia Goncharova, evening coat (detail). Silk. French, c.1925.
V&A: T.157-1967. © ADAGP, Paris and DACS, London 2002.

47 FAR RIGHT
Natalia Goncharova, dress. Silk appliqué. French, 1924–6. Made by Myrbor.
V&A: Circ.329-1968. © ADAGP, Paris and DACS, London 2002.

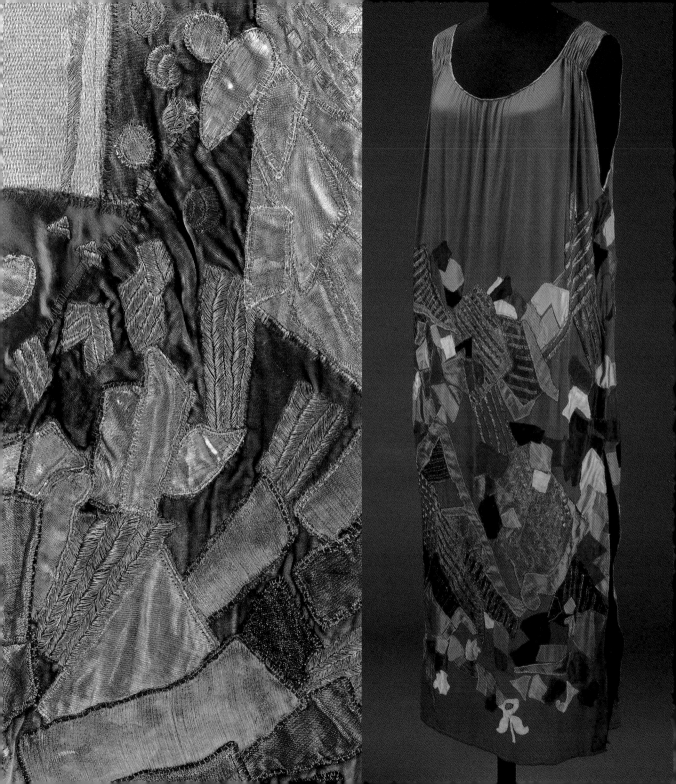

Sonia Delaunay

Ukrainian-born Sonia Terk left St Petersburg for Paris in 1905 where she studied art and married the painter Robert Delaunay. In 1911, as she was assembling pieces of material to make a traditional Ukrainian bedcover for her newborn child, she realized that the process, similar to abstract painting, could be applied to dress as well. Up to the War, using the same technique, she conjured stunning garments with abstract appliqués which she called 'simultané'.

The Delaunays were living in Spain when Sonia's income from Russia was cut off because of the Revolution. To earn a living, she started selling her 'simultaneous' shawls, handbags and cushions. Back in Paris, she was commissioned to design 50 abstract fabrics for a silk manufacturer from Lyons. She could now open an atelier with the couturier Jacques Heim, hiring Russian women to embroider fabrics to her designs. Sonia began to produce her first embroidered coats, executed in the 'point du jour' which she developed from the traditional 'point de Hongrie', using wools or silks in graded and nuanced colours mixed with black and white. At the Salon d'Automne of 1924, she presented her fabrics on rotating devices, eclipsing all the other designers at the event. At the 1925 Paris Exhibition she displayed dresses, coats, hats, handbags, umbrellas and curtains in her 'Boutique simultanée', which became the focus of the whole exhibition. Her career was launched.

In 1926, she began to design printed fabrics based on her experiments with embroidery. Her sources of inspiration were legion, and included African, Oriental, Slavic, antique and archaic motifs and colours. Like the Constructivists Popova and Stepanova, Delaunay wanted to express dynamism through the juxtaposition of elementary forms in contrasting colours. A known adept of

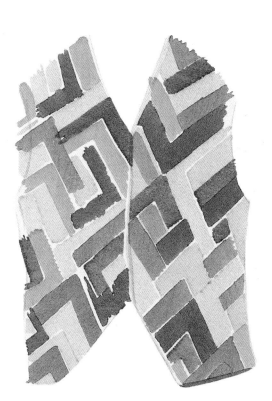

the tango, the charleston and jazz, she also tried to express rhythms using visual effects.

Sonia Delaunay went on designing extremely modern daywear, sportswear and beachwear until the end of the 1920s. The impact her style and colour schemes had on Art Deco fashion was enormous, and many regard her as the personification of avant-garde fashion.

48 ABOVE
Drawing by Sonia Delaunay. Gouache on paper. French, 1923.
V&A: E.9-1980.

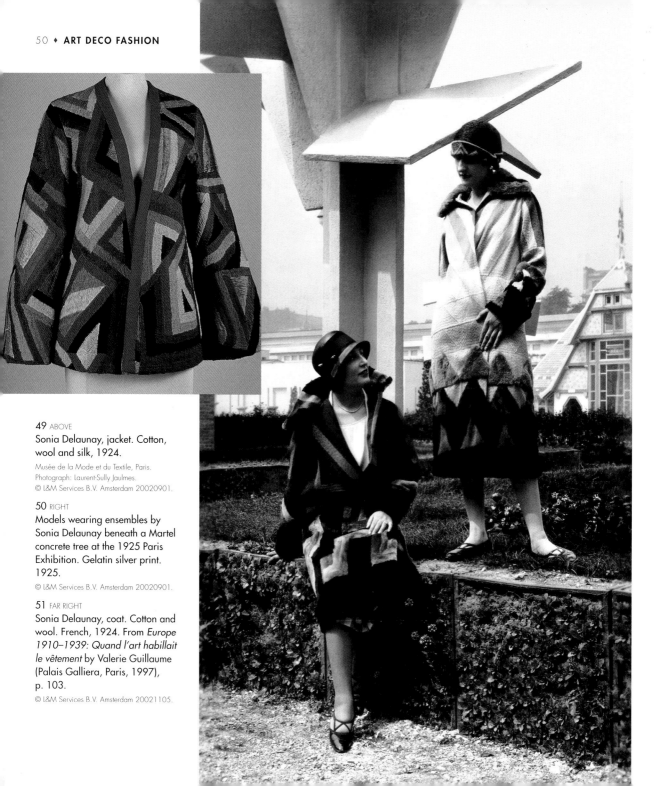

49 ABOVE
Sonia Delaunay, jacket. Cotton,
wool and silk, 1924.
Musée de la Mode et du Textile, Paris.
Photograph: Laurent-Sully Jaulmes.
© L&M Services B.V. Amsterdam 20020901.

50 RIGHT
Models wearing ensembles by
Sonia Delaunay beneath a Martel
concrete tree at the 1925 Paris
Exhibition. Gelatin silver print.
1925.
© L&M Services B.V. Amsterdam 20020901.

51 FAR RIGHT
Sonia Delaunay, coat. Cotton and
wool. French, 1924. From *Europe
1910–1939: Quand l'art habillait
le vêtement* by Valerie Guillaume
(Palais Galliera, Paris, 1997),
p. 103.
© L&M Services B.V. Amsterdam 20021105.

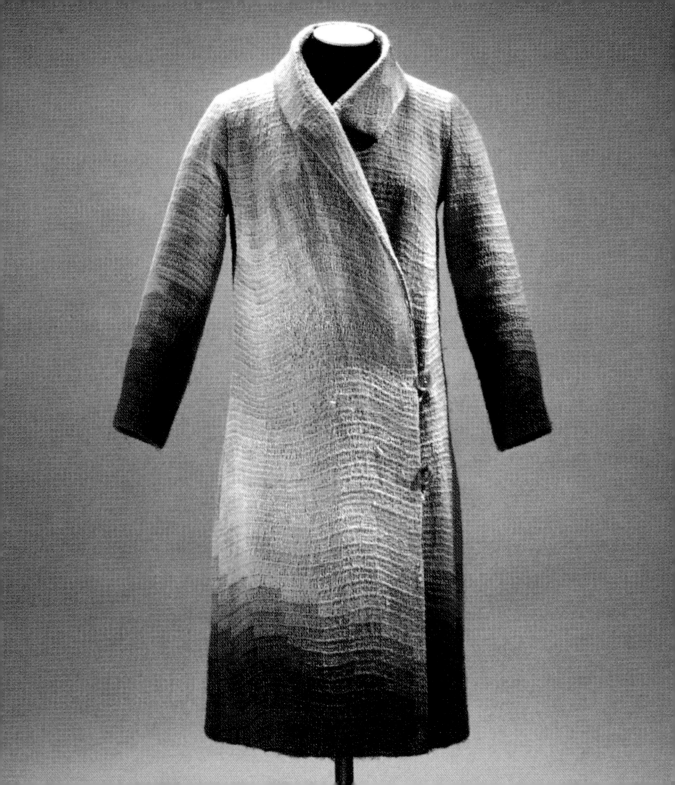

SPORTSWEAR
••••••••••••••••••••••••••••••••••••••

The 1920s saw the emergence of elegant leisurewear to complement the increasing popularity of sports. With their sumptuous dance costumes, the Ballets Russes had already proved that movement and elegance could be compatible, paving the way for a more comfortable fashion.

Fleeing the War in the seaside resorts of Biarritz and Deauville, wealthy crowds were discovering sports and outdoor activities, for which they needed freer, more comfortable yet elegant clothes. Jean Patou would be the first designer to transcribe this new spirit into fashion: by combining jersey with the strict lines of wartime clothes, he created the first stylish sportswear. Patou found in Chanel a fierce competitor, both of them aiming to dominate this new field. Throughout the decade they maintained an open rivalry, which both probably found highly inspirational.

Patou went on designing elegant ensembles for beach and mountain, but perhaps his most renowned design was the all-white ensemble with the bright orange bandeau he created for the tennis star Suzanne Lenglen to wear at Wimbledon in 1922. Patou opened the first house of couture to specialize in fashionable sportswear, and this had a strong influence on the modernization of daywear fashion. Dressed by Patou on the court as well as in town, Lenglen became the first sports icon to promote a fashion label.

Because of its simplicity and modernity, sportswear proved to be the ideal vehicle for the avant-garde's experiments with cut and design. Sonia Delaunay produced brightly embroidered beachwear, easily recognizable in glamorous resorts because of its colour schemes and level of abstraction. Her astonishing Cubist designs influenced all the designers of the period and permeated mainstream fashion.

52 RIGHT
Tennis dress. White and green linen. English, c.1925.
V&A: T.260-1975.

53 FAR RIGHT
Suzanne Lenglen, Wimbledon July 1922.
Hulton Archive/Getty Images.

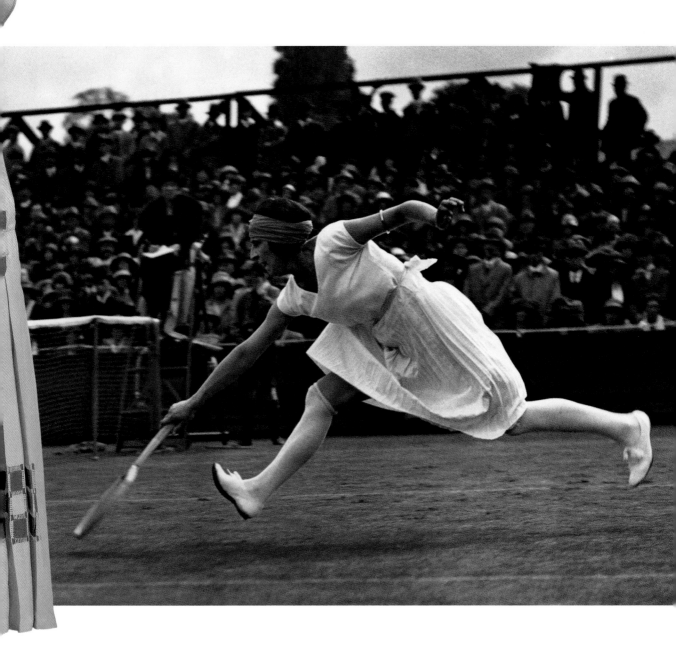

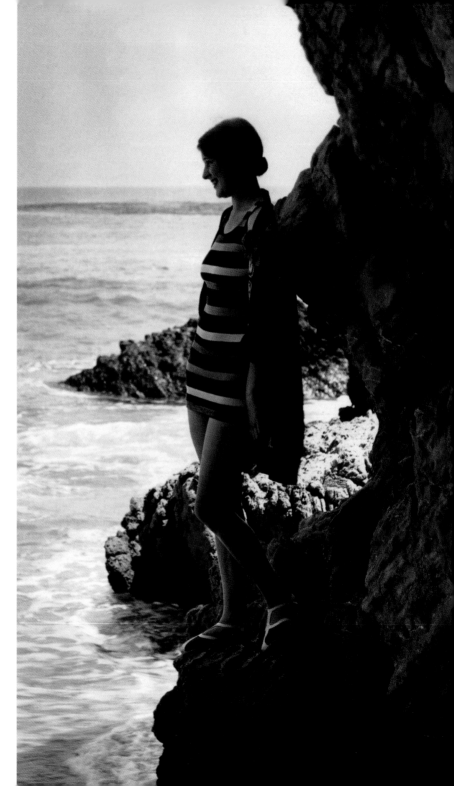

The decade saw the establishment of pyjamas as sophisticated lounge-wear or beachwear. Originating with the Ballets Russes and Poiret's harem pantaloons, they were also favoured by the avant-garde as the embodiment of comfort and practicality. Part of the 1920s passion for exoticism, they displayed beautiful hand-painted motifs from China or Japan.

Sportswear played a decisive role in the modernization and simplification of fashion. Softer fabrics allowing maximum freedom, such as kasha, morocco, jersey and silk, began to swamp the collections. New colour combinations borrowed from tennis and sailing – white and navy, white and red, or yellow and green – were now worn in town. Stylized motifs such as polka dots and stripes, together with the general sobriety inherent in sporting styles, permeated daywear, heralding the more restrained fashion of the next decade.

54 RIGHT
Bathing costume, c.1929.
Hulton Archive/Getty Images.

55 FAR RIGHT
Petit gamin, crêpe de Chine sports outfit by Charles Frederick Worth. From *Art, Goût, Beauté: feuillets d'élégance feminine,* no. 108, 1929.
NAL.

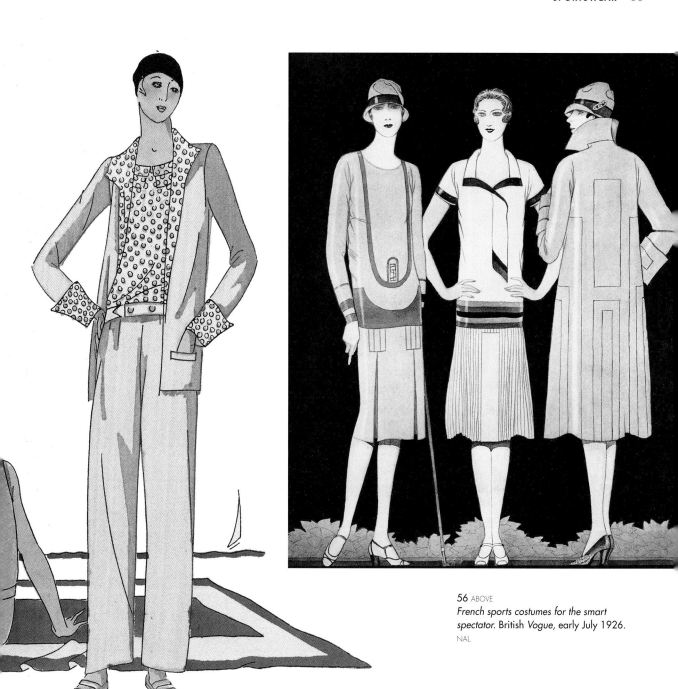

56 ABOVE
French sports costumes for the smart spectator. British Vogue, *early July 1926.*
NAL.

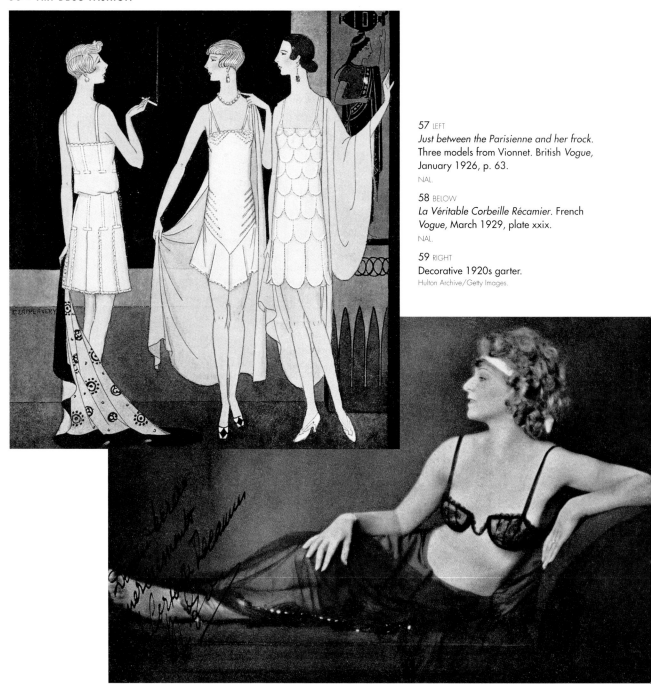

57 LEFT
Just between the Parisienne and her frock.
Three models from Vionnet. British *Vogue,*
January 1926, p. 63.
NAL.

58 BELOW
La Véritable Corbeille Récamier. French
Vogue, March 1929, plate xxix.
NAL.

59 RIGHT
Decorative 1920s garter.
Hulton Archive/Getty Images.

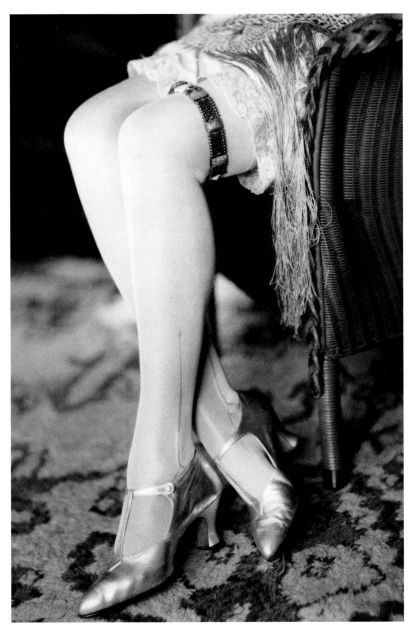

UNDERWEAR
••

Underwear was simplified during the War in favour of the one-piece camisole with legs, and the slip. Whalebone corsets were discarded and replaced in the 1920s with elastic stretch corsets covering the hips. Straighter and flatter dresses dictated an androgynous silhouette, and well-endowed women would flatten their breasts with bandages to obtain the required shape.

Old-fashioned white cottons and linens were replaced by silk and crêpe de Chine, often in white or pink, or sometimes black for more daring women. Rayon, a cheaper alternative to silk, helped to popularize the elegant pyjamas which, while exoticism was still fashionable, were worn as outer garments as well as for evening-wear.

As hemlines rose, legs became the new focus and attention fell on stockings. Ribbed and patterned, made out of cotton, wool, silk or rayon, they were held up by decorative metal garters.

By 1929, the bosom made a shy reappearance and women started wearing a 'combination corset', which was a brassière and girdle in one, supported by a few light bones. It was at this time that the first wired bras appeared.

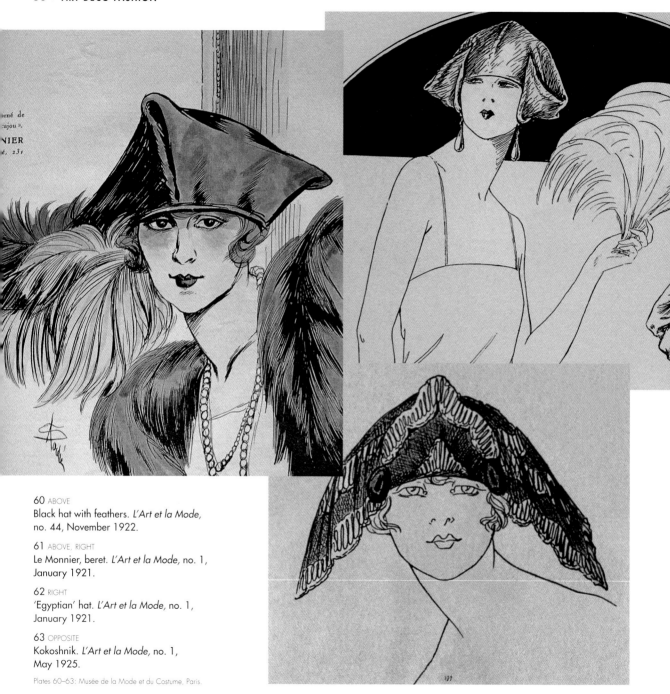

60 ABOVE
Black hat with feathers. *L'Art et la Mode,*
no. 44, November 1922.

61 ABOVE, RIGHT
Le Monnier, beret. *L'Art et la Mode,* no. 1,
January 1921.

62 RIGHT
'Egyptian' hat. *L'Art et la Mode,* no. 1,
January 1921.

63 OPPOSITE
Kokoshnik. *L'Art et la Mode,* no. 1,
May 1925.

Plates 60–63: Musée de la Mode et du Costume, Paris.

HATS

In 1907, to complement the slender silhouette of his Directoire dresses, Paul Poiret – 'who hated hair' – put women in turbans and classical bandeaux, setting a trend for hugging headdresses and totally concealed hair.

During the War, narrow and tall draped toques were created, to be worn with the high collars then in fashion. Wider hats were still worn for a more feminine look, but they started to display a square and deep crown. Worn very low on the forehead, they kept the hair completely out of sight.

The end of the War was marked by a wave of historicism in fashion and in millinery. At first worn by War widows who covered them with black veils, tricornes and bicornes were soon adopted for daywear by sophisticated women. In 1920, following the general trend for asymmetrical hats, the bicornes and tricornes began to evolve into the most extravagant forms, and were sometimes called 'Egyptian' hats because of their vague resemblance to the pharaonic headdress. They were now made of soft draped fabrics, showing elongated and crooked points, covered with rich embroideries, tulle, or black drooping feathers. Women wore them pulled down to the eyebrows, as was the fashion. Later on, the points of the bicorne were attached to the front or the sides of the crown, to suit the fashion for small and more streamlined hats.

The first years of the decade saw the most eclectic variety of hats. Sources of inspiration were legion, and were interpreted more freely in millinery than in dress: milliners created hats inspired by Chinese toques, Oriental turbans, Turkish, Egyptian and Russian headdresses, such as the famous *kokoshnik*. Traditionally a crown-like festive headdress covering the forehead, the *kokoshnik* was introduced by the Russian *émigrés*, and reinterpreted by all the French designers as a daywear hat. It also gave its shape to the legendary tiara of the 1920s, worn for balls, weddings, state and evening functions. The *kokoshnik* was highly dramatic. Worn low on the forehead, it drew attention to darkened eyes. It also sported exotic embroideries and stylized jewellery, or was surmounted with glycerine-coated ostrich feathers (an *aigle*). The *kokoshnik* was also sewn on to turbans, toques and cloches.

The combination of two kinds of hats, superimposed over each other,

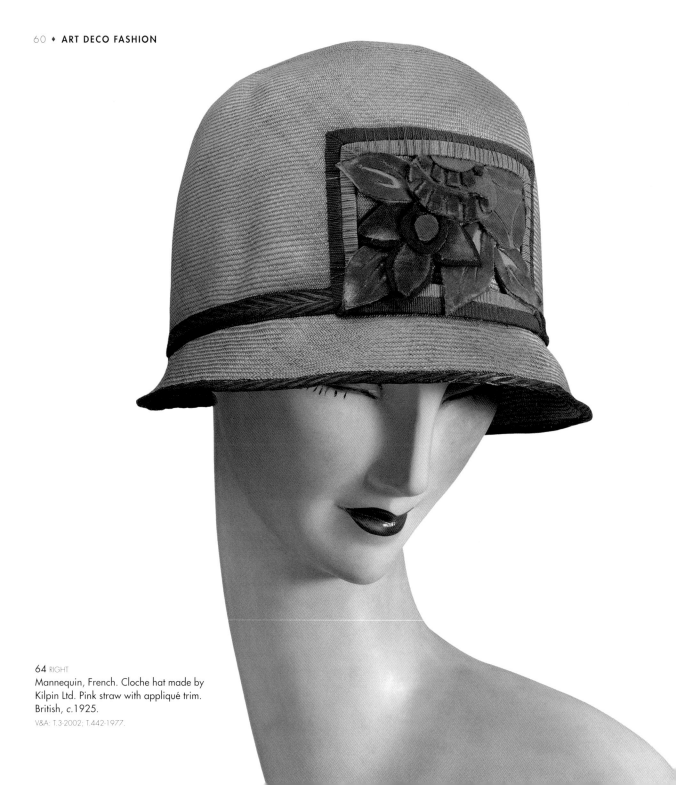

64 RIGHT
Mannequin, French. Cloche hat made by
Kilpin Ltd. Pink straw with appliqué trim.
British, c.1925.
V&A: T.3-2002; T.442-1977.

65 BELOW
'1916'. From *In Vogue: 60 years of fashion and celebrity from British Vogue* by Georgina Howell (Penguin, London, 1978), p. 20.
NAL.

66 RIGHT
Hat with ribbons. *L'Art et la Mode,* no. 45, November 1924.
Musée de la Mode et du Costume, Paris.

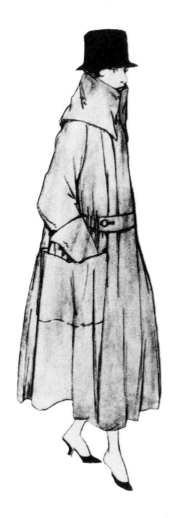

was often seen in 1920s millinery, especially in the creations of Madeleine Panizon, Caroline Reboux and Madame Agnès, who approached millinery as sculpture. Madame Agnès, herself an avant-garde fashion icon, collaborated with Fernand Léger, Mondrian and the lacquer artist Jean Dunand.

The cloche is probably the most iconic hat of the 1920s, but contrary to popular belief it is not a product of the 1920s. It was already being worn in 1916, with its characteristic deep crown and small brim. Pulled down very low over the eyes, and worn with a trench-coat, it created an early *garçonne* look. Often a forerunner of women's fashion, little girls' wardrobes already included the 1920s' cloche before the War years.

During the 1920s, cloches were made of straw, fabrics and especially felt. The high, bulbous crowns lent themselves to experimentation with pleating, beading, embroidery, appliqués and trimmings. The 'tweed' straw, created to match the suit of the wearer, was obtained by painting a tweed motif on the cloche, or weaving different colours of straw together. Although they were held to be brimless, cloches had small frontal brims from 1922 to 1925, and longer and asymmetrical brims from 1926 onwards.

Around 1925, the racing helmet inspired a new form of headdress for

women. Made of felt, and gripping the head tightly, the '*casque*' was also made of lamé or beaded net for evening-wear.

Alongside smaller hats, broad-brimmed, more romantic-looking hats ('*capelines*') were worn with light summer dresses or at the beach. Usually made of straw and decorated with silk flowers or ribbons, their shape didn't vary much in subsequent years.

A classic children's headdress since the beginning of the century, the Basque beret was picked up in the

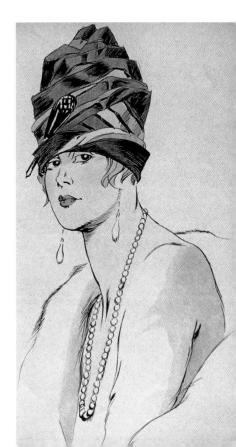

mid-1920s by fashionable holiday-makers in Biarritz. In town, the beret was clasped on one side with an elegant brooch known as the 'fléchette'. In 1929, it shrank into a head-hugging bonnet, often crocheted, and worn with elegant suits. The beret, a headdress borrowed from the working-class, would attain a very high degree of sophistication in the 1920s and become the most popular hat of the 1930s.

By 1929 hats had shrunk and become very stylized. The fashion magazines, however, would write about the general 'asymmetry and complexity' of millinery (*Vogue Paris*, March 1929). The cloches were still extremely popular despite strong attempts from milliners to discard them. They were now cut high on the forehead, or had their frontal brim attached to the crown, showing more of the face. Longer brims were worn on one or both sides, mostly in an uneven manner, sometimes pinned up to the hat. A sign of the times, the *voilette*, or veil, returned in 1929, giving a mature slant to the *garçonne* look, and heralding the sophisticated fashion of the coming years.

67 RIGHT
Photograph of four women sitting on a boat, 1928. From *The Vogue Book of Fashion Photography* by Polly Devlin and Alexander Liberman (Thames and Hudson, London, 1979), pp.32–3.
NAL.

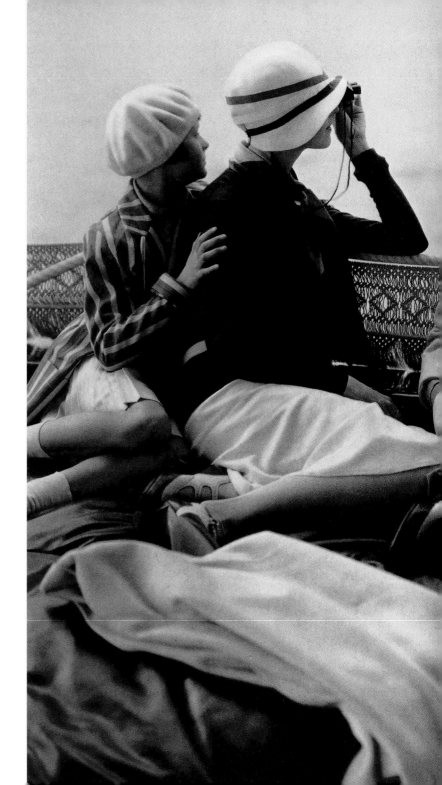

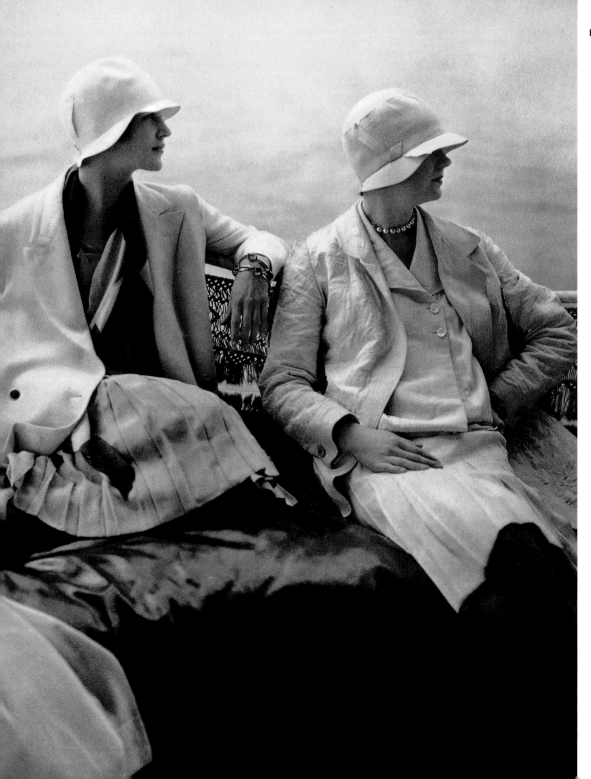

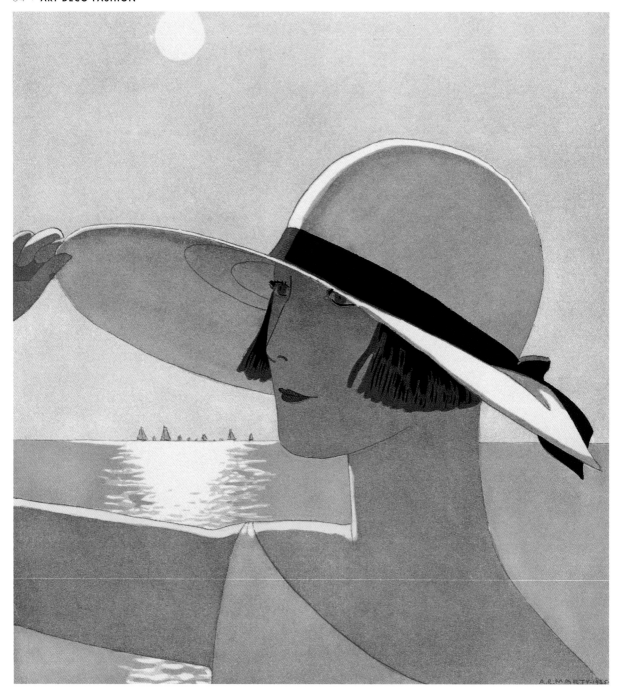

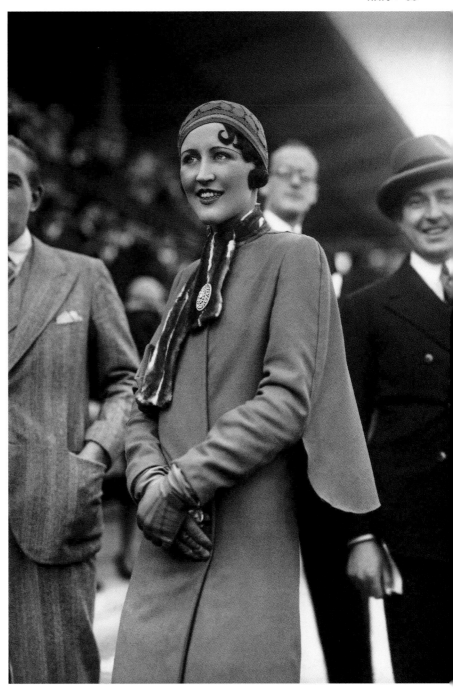

68 LEFT
Sur la digue, hat by Marthe Collot.
Illustration by André Marty. *La Gazette
du bon ton,* no. 6, 1924/25, plate 45.
NAL.

69 RIGHT
Molyneux. Photo Seeberger,
no. 226, 7 April 1929.
Bibliothèque nationale de France.

BAGS

••

The absence of pockets on the slim dresses of the 1920s gave a new importance to bags. Women were more active and more sophisticated than ever; they worked, travelled, drove cars, and would not survive without their lipstick or cigarettes. Their bags had to carry everything and still look fashionable and not too bulky.

For the day, a flat pochette was worn under the arm or held in the hand. Highly decorative and modern, it was usually made of leather and reflected the many sources of Art Deco (China, Ancient Egypt, Africa and Cubist art). For the evening, pochettes and pouches were cut in rich fabrics co-ordinated with the dresses.

70 LEFT
Cylindrical purse made by J.A.C. Black lacquer and diamanté. British, 1929.
V&A: T.30-1981.

71 RIGHT
Green felt bag with Egyptian motifs, gold purse. English, c.1920.
V&A: T.236-1972; T.236A-1972.

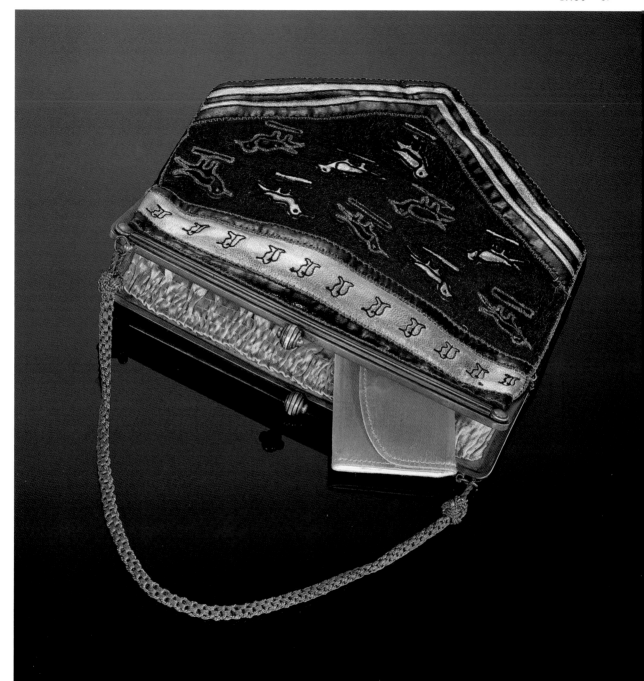

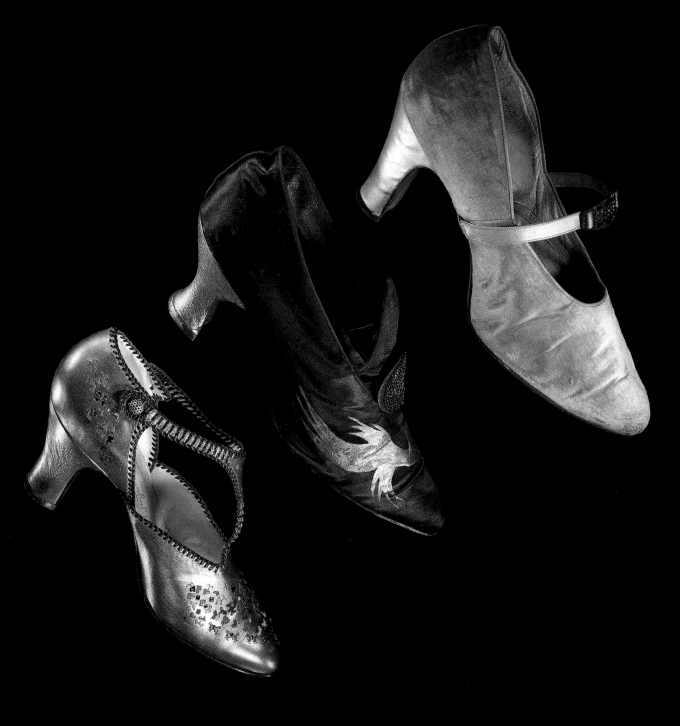

SHOES

••••••••••••••••••••••••••••••••••••

The 1920s produced the most exciting shoes of the century, with a tremendous variety of cut, colour and ornamentation. With shorter skirts, legs and feet were now on display and shoes became the focal point of fashion. Women wanted coloured stockings and new shoes, especially after the sombre and practical styles of the War.

During the 1920s, fashion changed rapidly and shoemaking had to follow closely, producing a legion of styles. Most shoes were high-heeled, even for dancing, necessitating straps over the inset. Later styles included tongues, cutaways, T-bars and crossover straps.

The exotic influences of the early 1920s produced real 'walking jewellery' made of pearl-embroidered silks and gold kid, with carved heels and Egyptian motifs. Embroidered versions of harem slippers were also very popular. Shoemakers such as Perugia and Salvatore Ferragamo attained the status of 'shoe designers' and were designing for major fashion houses, as well as for actresses and stars of the music hall.

With the popularity of outdoor sports came the more practical low Cuban heels in 1922, and the innovative sandals made by Ferragamo in 1923. Perugia followed with elegant high-heeled sandals for evening-wear, and Chanel with the slingback sandal. The increasing popularity of beachwear led to the creation of colourful, Cubist-inspired rubber shoes.

Bright colour mixes reached a peak for the 1925 Paris exhibition, but modern fashion was already moving towards greater subtlety. Ferragamo had discovered that, by inserting a thin strip of steel inside the sole to support the arch, he could make a slimmer and more elegant shoe. In 1927, the new indoor shoes were made of patent leather, dubbed *'azuré'*, or *'nacré'*. Silvered kid had replaced gold kid. Browns, greys and greige became fashionable, while the first crocodile and lizard shoes were created by Perugia at the end of the decade.

72 LEFT
A. Rambaldi, kid shoe with painted design. **Monaco, *c*.1925.** V&A: T.313-1975.

Stead and Simpson, satin shoe with hand-painted bird motif. British, 1922. V&A: T.737B-1974.

Rayne, woman's shoe. Green velvet with satin heel and diamanté fastening. British, *c*.1928. V&A: T.142:2-1997.

73 BELOW
Le Bottier de L'Elégance. Art, Goût, Beauté, no. 55, March 1925.
NAL.

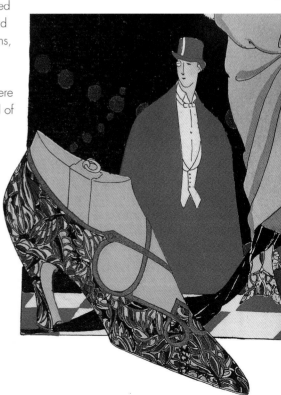

MAKE-UP
••••••••••••••••••••••••••••••••••••••

At the beginning of the twentieth century, significant advances in the pharmaceuticals industry facilitated the development of a market for beauty products. Theatre and film stars were used to promote powder and kohl, thereby introducing the concept of fashion into make-up.

Until the end of the War, the ideal of feminine beauty remained anaemic and androgynous: white faces and eyes blackened with mascara, with eyebrows left unplucked, and no trace of lipstick. In 1919, however, models had their faces made-up in a new style that recalled Japanese prints: white powder, black kohl and mascara, thinly drawn eyebrows and heart-shaped deep-red mouths. That same year, Polish-born Max Factor, now based in Hollywood, developed the first ever line of harmonized products: powder, rouge, eye shadow and lipstick. Following the different trends in fashion, the feminine face would evolve from the pale and languid *odalisque* of the early 1920s, to the tanned *garçonne* look of 1925 and finally to the sophisticated *femme fatale* of the late 1920s.

Abstract painting, fashion illustration, photography and cinema would all have a major impact on make-up and hairstyles during the 1920s. Their sharp and highly decorative depiction of women's bodies, dresses and faces as flat blocks of violent colours, and hairstyles as metal or plastic, would influence make-up and hairstyles for the coming decades.

With short hair and hats worn low on the forehead, eyes naturally stole all the attention. Eye make-up became more sophisticated: vaseline was rubbed on the eyelids to attract the light, eyes were contoured with a blue or brown pencil line, and black mascara and eyebrow pencil were applied to give a mysterious look. Lipstick colours ranged from extremely pale for highlighting fashionable suntans, to dark burgundy.

In response to the vogue for sports and fitness, beauty companies focused on clean and healthy skin. Elizabeth Arden, Helena Rubinstein and Harriet Hubbard Ayer brought out cleansing milks, creams, astringents, tonics and tanning lotions. By the mid-1920s, make-up, which used to be associated with vulgarity, had become synonymous with elegance and confidence. Putting on powder and lipstick in public now represented the ultimate in sophistication.

The fashions of the 1920s demanded new beauty practices: the tubular dresses of the period looked

74 RIGHT
Max Factor instructs English film star Dorothy MacKaill in the art of applying her make-up, 1930.
Hulton Archive/Getty Images.

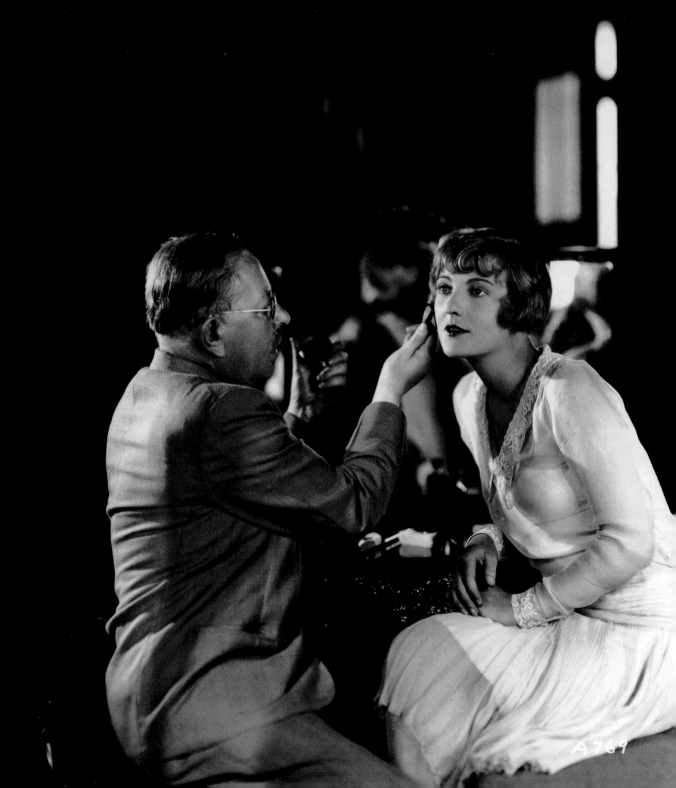

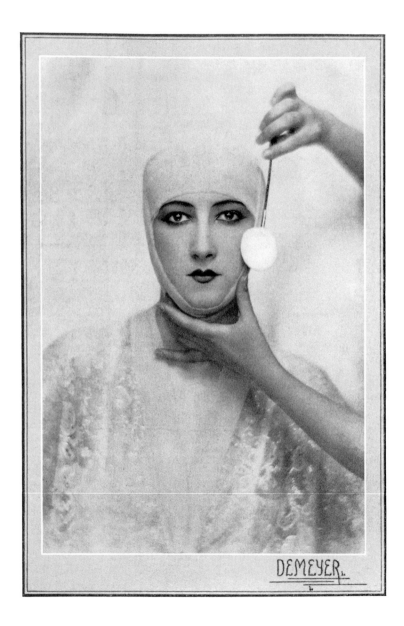

best on slim women, a vision enforced by the new 'abstract' fashion photography. Losing weight became an obsession. The fight against weight engendered a whole range of products and machines that promised to slim and tone. Because of the shorter, sleeveless dresses and swimsuits, women began to shave their legs and armpits and some had their arms and ankles painted with garlands of roses.

Another prolific fashion industry focused on perfume, especially since fashion designers had begun to create their own brands. After Poiret in 1911 with *Rosine*, Chanel followed in 1921 with *No. 5*, and Jeanne Lanvin with *My Sin* (1925) and *Arpège* (1928). Lanvin built her own perfume laboratories, and asked the designer Armand Rateau to create the famous black ball bottle for *Arpège*, while Baccarat and Lalique produced elegant glass bottles, vital accessories for every dressing table. Other famous perfumes of the times were *L'heure bleue* (1912), *Mitsouko* (1919) and *Shalimar* (1925) by Guerlain.

75 LEFT
Baron Adolph de Meyer, advertisement for Elizabeth Arden cosmetics. British *Vogue*, September 1927.
NAL.

76 RIGHT
Paris Fashions and Brides. Cover of British *Vogue*. January–July 1926.
NAL.

HAIR

••••••••••••••••••••••••••••••••••••••

Hair followed fashion very closely, progressing from the exotic styles of the early 1920s, to short and straight, around 1925, and then to short and waved at the end of the decade.

During the 1920s, hair was cut closer to the head, a trend that had begun shortly before the War. In 1917, Chanel cut her hair in a bob to promote her sporty look. At that time, however, women with short hair were still in a minority, and the public generally favoured locks 'à la Mary Pickford'.

After the War, the arrival of the tango was accompanied by a fashion for tight chignons fixed to the nape with wide combs. These low chignons and rolls were ideal for the deep hats and cloches of the period. This very neat, sharp look would mark the move towards the short haircuts coming into vogue.

By 1924, many women had adopted the new, shorter cut in one of its variations – the square bob with fringe, parted in the middle, or slicked back with gel. The famous 'coiffeur'

Antoine, whose clients included Greta Garbo and Josephine Baker, perfected the short shingle cut, presented at the exhibition in Paris in 1925. The 'Dutch boy' cut, immortalized by the film star Louise Brooks, was based on toddlers' haircuts. Her very stylized and photogenic dark mass of hair, cut in angles and straight lines, captured the essence of the Art Deco look, and was copied by thousands of women.

By 1927, the straight lines were softening, in fashion as well as in hairstyling. Women were waving their hair, creating a more feminine style that was to take off during the 1930s.

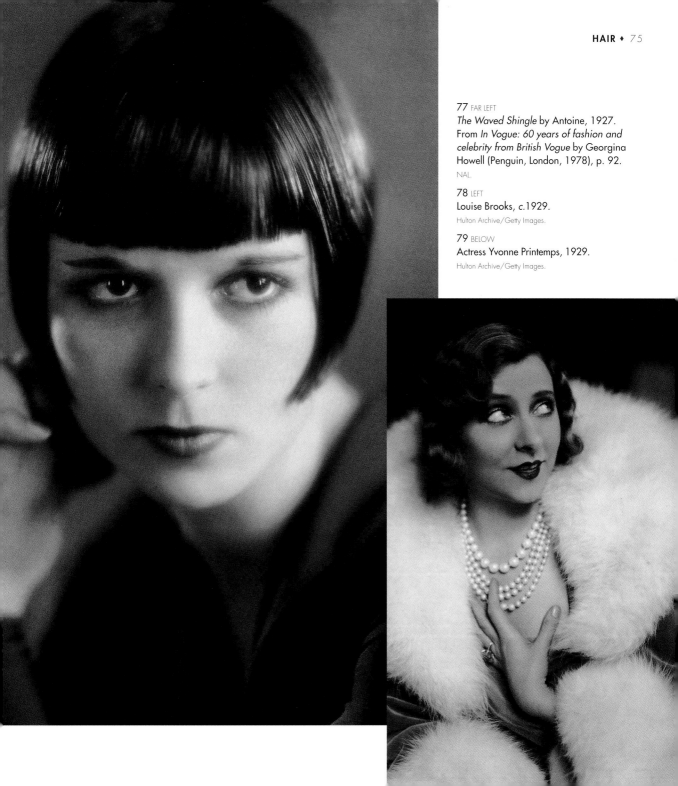

77 FAR LEFT
The Waved Shingle by Antoine, 1927.
From *In Vogue: 60 years of fashion and
celebrity from British Vogue* by Georgina
Howell (Penguin, London, 1978), p. 92.
NAL.

78 LEFT
Louise Brooks, *c.*1929.
Hulton Archive/Getty Images.

79 BELOW
Actress Yvonne Printemps, 1929.
Hulton Archive/Getty Images.

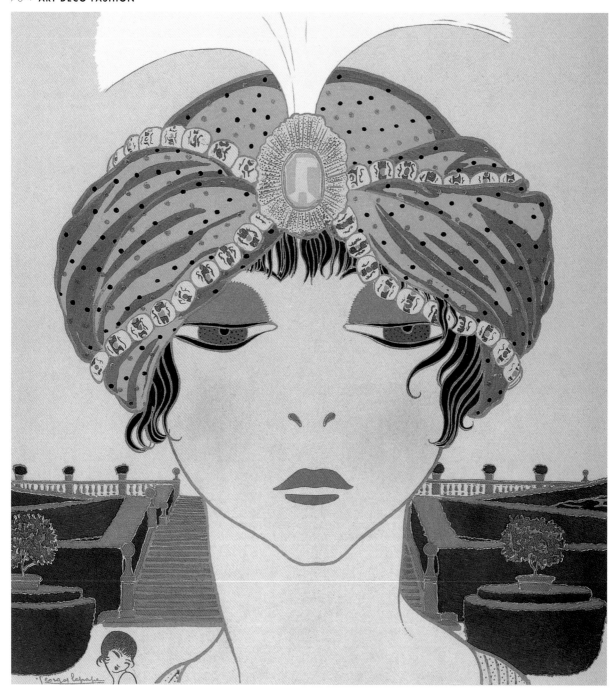

FASHION ILLUSTRATION

••••••••••••••••••••••••••••••••••••••

In 1908 Poiret asked Paul Iribe, a young avant-garde artist, to illustrate his first fashion collection in a luxurious hand-painted album. The result was revolutionary: borrowing from Japanese prints and Fauvist colours, Iribe painted the dresses in flat blocks of violent colours on empty backgrounds. More than a simple representation of the dresses, the plates were the illustrator's interpretation of Poiret's ideas. This innovative approach brought about a radical change in the relationship between designer and illustrator, and marked the beginning of a new era, heralding the birth of Art Deco illustration.

80 LEFT
Le Turban, from *Les choses de Paul Poiret,* 1911.
NAL.

81 RIGHT
Georges Lepape, *Modes et Manières d'Aujourd'hui,* 1912. From *The Golden Age of Style* by Julian Robinson (Orbis Publishing, London, 1976), p. 15.
NAL.

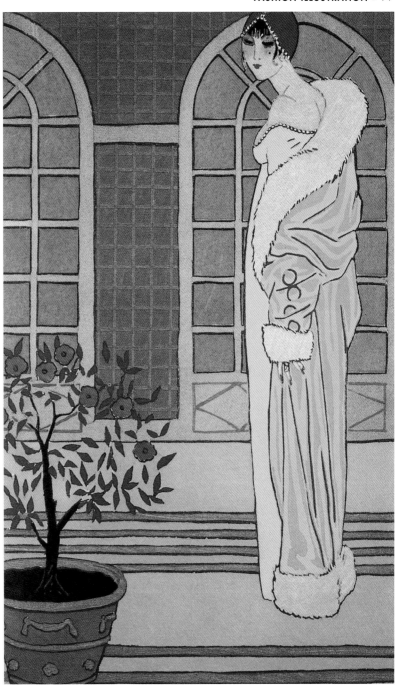

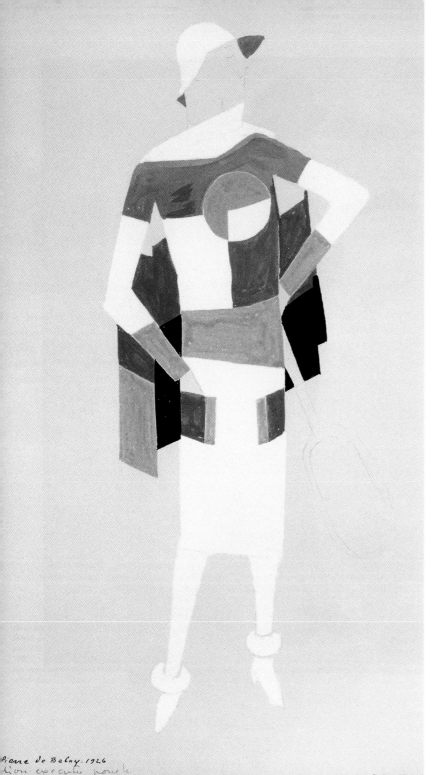

Pierre de Belay. 1926.
tion exécuté pour le

DONKEY CLUB

Poiret's second album, *Les choses de Paul Poiret vues par Georges Lepape,* was published in 1911. Lepape's work displayed – brilliantly – all the influences of the period: Matisse's blue skins, Modigliani's elongated silhouettes and Bakst's Orientalism, and it featured as well the first transcription of a cinematographic 'close-up' in fashion illustration (see plate 80). The influence of Japanese prints was also very evident in Lepape's style, not only in the flat blocks of colour but also, and most importantly, in the traditional Japanese pose, *mikaerie bijn* (literally, 'beauty looking behind'), which would itself have a huge influence on fashion photography.

Both these albums had a decisive impact on the emergence of new artistic fashion magazines. *La Gazette du bon ton,* founded in 1912, pioneered the idea of using the top artists of the day to illustrate the very best haute-couture designs. High standards of printing were maintained throughout its publication, until its last issue in 1925. Between 1912 and

82 LEFT
Pierre de Belay, 'création exécutée pour La Salon de la Mode', 1926. From *Les Dessins sous toutes coutures: croquis, illustrations, modèles, 1760–1994* (Palais Galliera, Musée de la Mode et du Costume, Paris, 1995), p. 118.
NAL.

1932, a legion of fashion magazines sprung up in Europe, *Art, Goût, Beauté, L'Art et la Mode,* and *Vogue,* illustrated by Erté, Dupas, Benito, Georges Barbier, André Marty and Charles Martin.

Back in 1911, Poiret had opened a gallery to exhibit fashion illustration as part of his mission to elevate fashion to the rank of art. In 1920, an exhibition organized to celebrate the work of fashion illustrators at the Museum of Decorative Arts was followed by the launching of the annual Salon de la Mode, where illustrators could present their work in a luxurious Parisian gallery.

Exotic illustrations in the style of the Ballets Russes ended with the War. A new style then emerged, showing brisk drawings combined with subtle colour contrasts. By the mid-1920s, elongated figures in streamlined dresses mirrored a slender, emancipated woman set against stylized backgrounds, showing how much illustration had absorbed of modern art styles. In the 1930s, fashion illustration, now competing with photography, had to be more realistic, in tune with Chanel's modern woman.

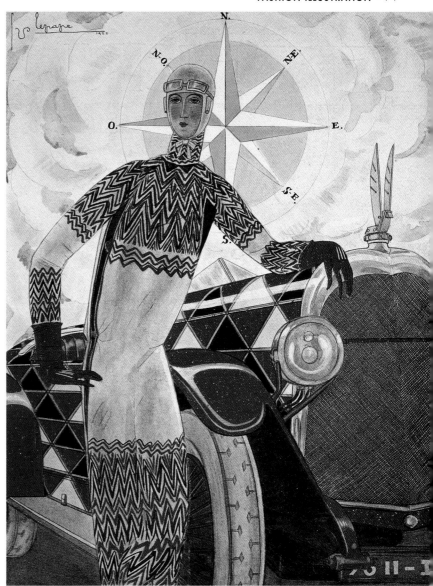

83 ABOVE
Georges Lepape, cover for British *Vogue,* showing a model wearing a Sonia Delaunay 'simultaneous' dress, next to a 'simultaneous' car. January 1925.

NAL. © ADAGP, Paris and DACS, London 2002.

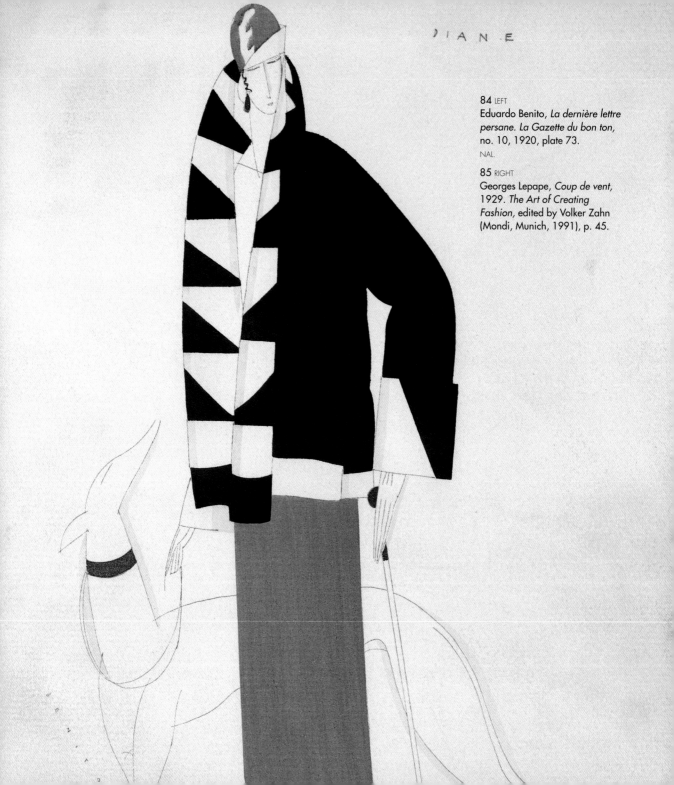

DIANE

84 LEFT
Eduardo Benito, *La dernière lettre persane. La Gazette du bon ton,* no. 10, 1920, plate 73.
NAL.

85 RIGHT
Georges Lepape, *Coup de vent,* 1929. *The Art of Creating Fashion,* edited by Volker Zahn (Mondi, Munich, 1991), p. 45.

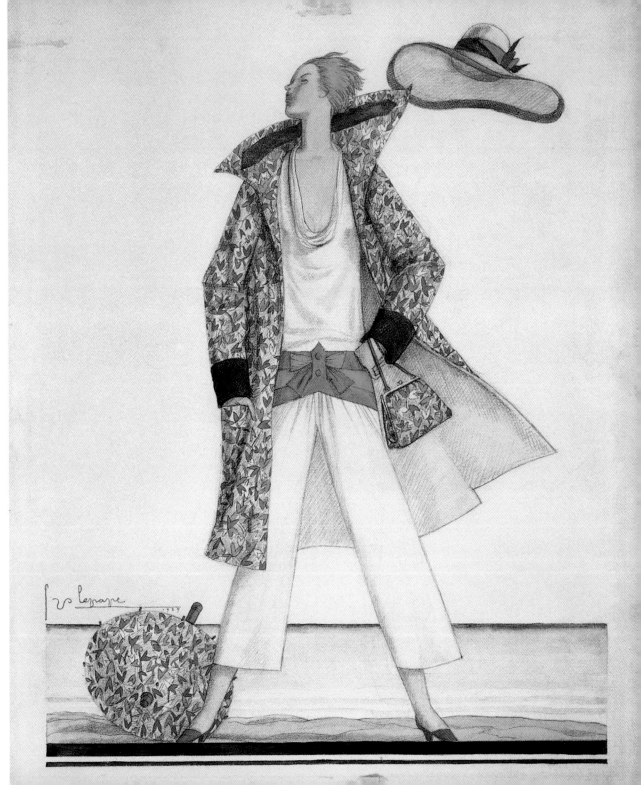

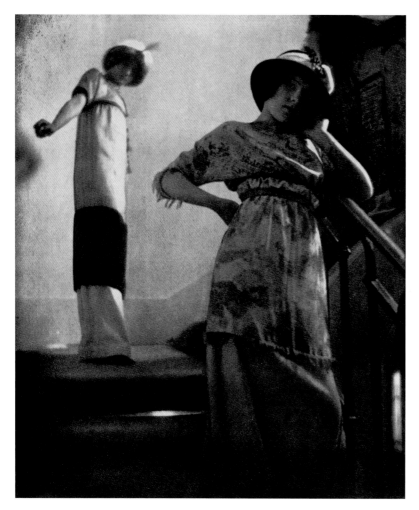

FASHION PHOTOGRAPHY

••••••••••••••••••••••••••••••••••••

The development of fashion photography is closely linked to the improvement of photographic techniques, and to the evolution of fashion and fashion magazines. In 1911, Poiret hired Edward Steichen, the leading photographer of the time, to shoot his latest collection. Steichen depicted the models interacting in soft-focus tableaux, and in doing so he created a new style of fashion photography that was clearly influenced by Georges Lepape's fashion illustration. The following year, Baron Adolph de Meyer was commissioned to photograph the Ballets Russes' most famous dancer Nijinski; both series were published in art magazines.

During the 1920s, *Vogue* hired talented photographers to shoot fashion designs. The most influential were the Surrealist, Man Ray, and George Hoyningen-Huene. Hoyningen-Huene's sharp style and brilliant feel for light proved the perfect means by which to express the

86 ABOVE
Edward Steichen, *Bakou et Pâtre*. American, c.1911. *Art et décoration,* April 1911.
NAL.

87 RIGHT
George Hoyningen-Huene, models wearing swimwear. Gelatin silver print. USA, 1930.
V&A: PH.723-1987.

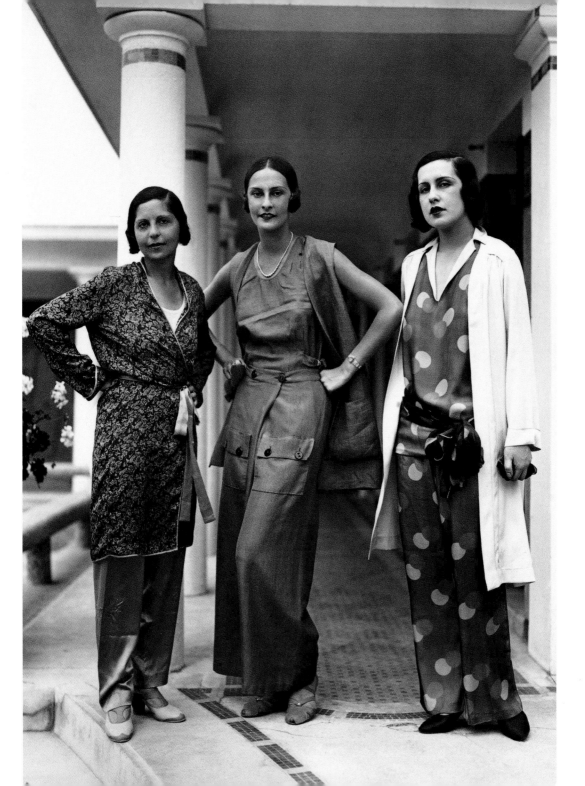

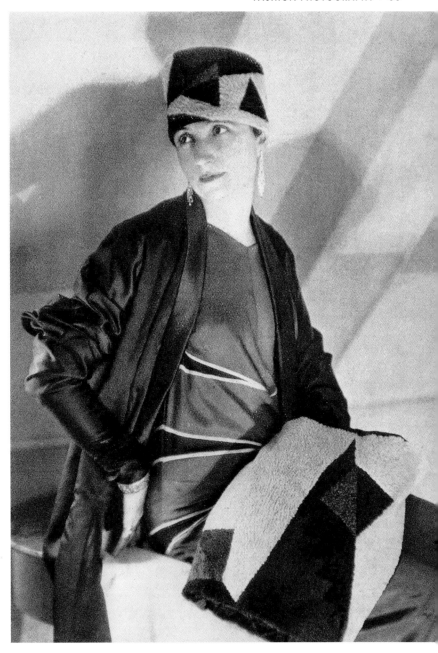

modernity of Cubist-inspired beachwear, set against minimalist backgrounds. More interested by the inspiring force of the shapes and lines of the clothes than by fashion itself, both Man Ray and Hoyningen-Huene infused fashion photography with their own aesthetic and technical inquiry.

Photography was also used to document fashion as early as 1909, when the three Seeberger brothers, Jules, Louis and Henri, began to photograph elegant women in designer clothes at the races in France.

Fashion designers began to use the new medium to document and protect their designs during the 1920s, and by the end of the decade – a true sign of the times – photography had replaced fashion drawings in the designers' archives. Because of its cost, however, it was not until the 1960s that photography ousted illustration in the fashion magazines.

88 LEFT
Au centre Schiaparelli à Deauville.
Photo Seeberger, no. 37, 28 July 1929.
Bibliothèque nationale de France.

89 RIGHT
Edward Steichen, photograph of Madame Agnès. British *Vogue*, September 1926.
NAL.

CINEMA
••••••••••••••••••••••••••••••••••

Between the wars, and especially during the 1920s, many fashion designers worked in cinema, creating new costumes or lending gowns from their collections. The medium gave them a unique opportunity to show their designs in motion, and to a much larger audience.

Designing for the screen presented new challenges. The costumes had to be fluid and visually strong, faithful to the script, easy to read without either colour or sound, yet still reflect the designers' style.

An ardent believer in the synthesis of the arts, the director Marcel L'Herbier brought the French artistic avant-garde together for his film *L'Inhumaine* (1924) which told the story of a cruel and selfish woman. Robert Mallet-Stevens and Fernand Léger were responsible for the sets, Darius Milhaud composed the music, Pierre Chareau designed the furniture and Raymond Templier the jewellery, and Paul Poiret created the costumes.

In silent movies, costumes, make-up and sets were the only means available to express mood, character and plot. Influenced by the aesthetic of German Expressionist cinema, L'Herbier's team used bold sets and extravagant costumes and make-up to express character and the drama of the scene.

To depict the cruelty of the main character, and to complement the Cubist sets and geometrical light effects, Poiret designed straight dresses and coats using bold, geometrical and sharp, linear motifs. The headdress, an *'aigle'* made of black drooping feathers, and the black monkey fur of the coat's collar, framed the actress's white face with a sombre halo of black spikes. For the men, Poiret designed waistcoats and plastic-coated overalls inspired by Futurist designs.

Poiret turned more and more to costume design, for here he found an outlet for his theatrical and eccentric style. In 1924, he designed the costumes for another heartless character in *Le Fantôme du Moulin Rouge,* using violently coloured fabrics designed by Dufy. From 1912 to 1929, he would work on a total of twelve films.

For his next film, *Le Vertige* (1926), Marcel L'Herbier asked Sonia and Robert Delaunay to design the costumes, fabrics and sets. Sonia created 'simultaneous' robes for the actors and a straight dress of black satin with colourful, stylized flowers appliquéd on bronze lamé for the leading actress. The paintings, furniture and fabrics had all been displayed at the 1925 exhibition.

Sonia worked on one more film, *Le P'tit Parigot* by René Le Somptier (1926), for which she created the costumes, the furniture and the fabrics. The whole movie is a testimony to her talent, and her creations can be seen in every scene. For the leading actress, the dancer Lizica Codreanu, Sonia created an extremely modern 'pierrot' costume, with multicoloured thunder lights and a huge collar made of superimposed circles of gauze. In one of the scenes, Codreanu dances in front of an audience wearing 'simultaneous' dresses and scarves.

In 1925, Jeanne Lanvin designed beautiful 1920s versions of Directoire dresses for Abel Gance's *Napoleon*. She also created two white picture dresses for *Feu Mathias Pascal* (L'Herbier, 1924). In 1929, Jean Patou designed a stunning bronze lamé flaring dress and coat trimmed with fur for the icon movie star Louise Brooks in G.W. Pabst's *'Lulu'*.

Film productions began to capitalize increasingly on glamorous fashion. Working in a colourless context, designers had to rely on shiny and

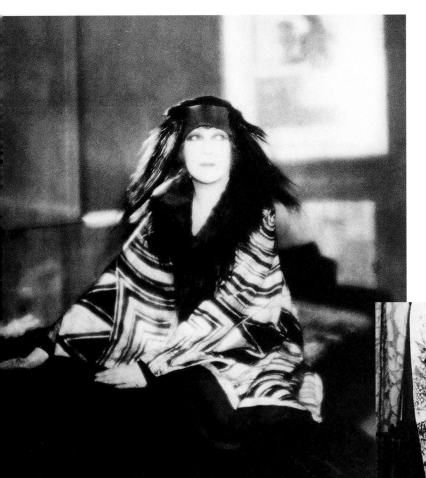

90 LEFT
Paul Poiret, coat, worn by Georgette
Leblanc, in *L'Inhumaine* (1924). From *Paul
Poiret (1879–1944)* by Yvonne Deslandres
(Editions du Régard, Paris, 1986), p. 86.

91 BELOW
Paul Poiret, outfit, worn by Madeleine
Rodriguès in *Le Fantôme du Moulin Rouge*
(1924). From *Maîtres de la Mode Art Deco*
by Nicole Groult (Palais Galliera, Musée de
la Mode et du Costume, Paris, 1986), p. 162.

textured fabrics for visual effect, such as lamés, sequins and boas, and explore the white and black spectrum, from white-platinum to shiny black. Black-and-white films demanded sharpness in costume and coiffure, and this would establish new references in haute couture and mainstream fashion.

American movie stars had a huge influence on fashion, and they helped to promote haute-couture designs. Most of the time, however, producers could only afford one or two haute-couture dresses, so some actresses bought their gowns directly from the designers and paid for them with their own money. Mary Pickford was known to go to Paris regularly, and there buy 50 haute-couture designs which she would wear indiscriminately in movies and in real life. American

92 BELOW
Sonia Delaunay, costume worn by Lizica Codreanu in *Le P'tit Parigot* (1926). From *Designing Dreams: Modern Architecture in the Movies* by Donald Albrecht (Thames and Hudson, London, 1987), p. 55.
NAL.

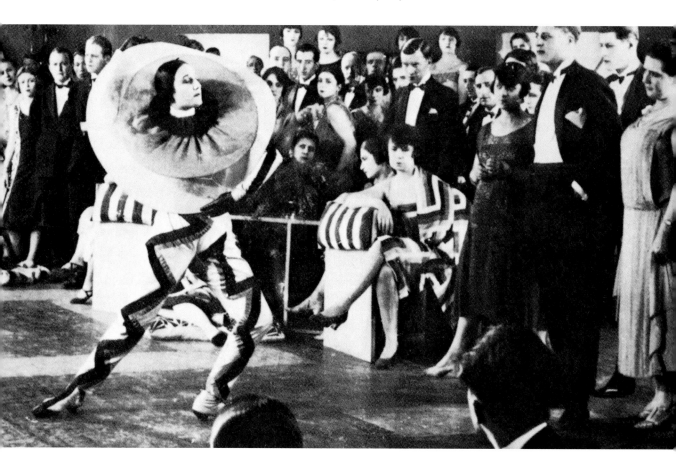

actresses were the first to create a style of their own: Lillian Gish with her pastel muslin dresses, Mary Pickford in 'little girl' dresses and Joan Crawford in garments by American fashion designers. Greta Garbo, with her cape and deep cloche, became the epitome of the late 1920s fashion in American cinema. Period movies and movies set in faraway locations played a major part in promoting exotic outfits.

The French illustrators Paul Iribe and Erté were amongst the first costume designers to work in Hollywood, but their sketches, magnificent on paper, did not translate well to the human body. In 1930, Chanel was offered one million dollars to dress Gloria Swanson, for her role in *Tonight or Never*, and off-screen as well. Her designs were judged 'not glamorous enough' for Hollywood, however, and seemed dated by the time the movie came out.

It had become clear that cinema needed its own fashion, borrowing the general lines of haute couture but without the details that could date quickly. Costume designers specializing in clothes for the cinema appeared in the 1930s, the most famous being the Americans Travis Benton and Adrian.

93 RIGHT
Jacques Manuel and Sonia Delaunay, dress for *Le Vertige* (1926), Marcel L'Herbier. From *Les Plus Belles Robes du Cinéma: la collection de la Cinématique Française* (Paris Musées, Paris, 2001), p. 48.

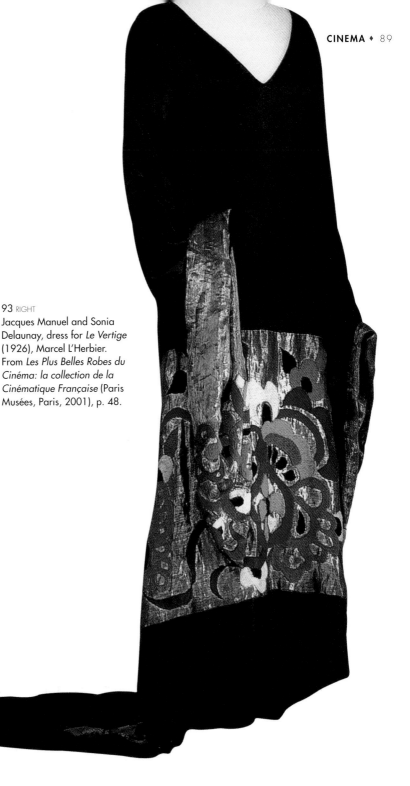

THE 1925 EXHIBITION

In April 1925, the Exposition Internationale des Arts Décoratifs et Industriels Modernes opened in Paris. It ran for six months, with the aim of showcasing France's artistic talents.

With Jeanne Lanvin, Jean Paquin and Paul Poiret on the board, fashion was given a prominent place, reaffirming Paris as the world leader in glamour and elegance. The luxury industries – fur, couture, perfume, glass, jewellery and interior furnishing – displayed their wares in four different locations.

The Pavillon de l'Elégance, created by designer Armand Rateau, hosted designs by Lanvin, Callot Soeurs, Jenny, Paquin, Vionnet and Worth. Luxurious gowns and mantles were mounted on a new generation of Siégel mannequins specially created for the event by designer André Vigneau.

Life-size replicas of fashion-illustration figures, these mannequins had sculpted hair, slanted and vacant, Brancusi-like eyes, tubular bodies and elongated limbs. They were painted in red, purple, gold, silver, bronze, black or natural wood colour. Sculpted in realistic poses – seated powdering their noses or stretching out in luxurious bedrooms – they left the visitors bewildered and slightly disturbed. Extensively photographed during the exhibition, most notably by Man Ray, the displays established the mannequin as a potent subject for artistic photography.

Alongside the tiaras and necklaces of Cartier, Boucheron and Van Cleef, Chanel presented her fur coats; children were dressed by Lanvin, and Madame Agnès displayed her toques decorated with lacquered motifs by Jean Dunand.

While the Pavillon de l'Elégance was reserved for traditional haute-couture, avant-garde fashion, represented by Sonia Delaunay, was exhibited on the 'Rue des Boutiques', along the pont Alexandre III. Jacques Heim's models, dressed with Sonia's stunning garments, were photographed in front of a car she herself had painted, as well as Cubist trees designed by Martel. Compared with the elegant but somehow dated fashion of the Pavillon de l'Elégance, Sonia's

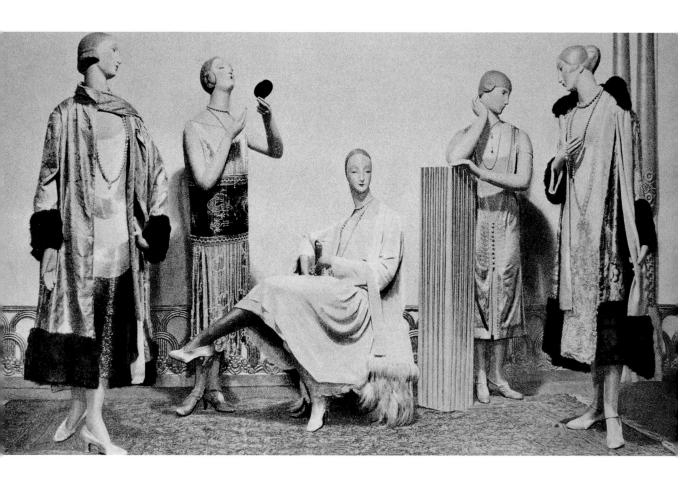

94 ABOVE
Mannequins in evening clothes by Jeanne Paquin in the 'Pavillon de l'Elégance' at the 1925 Exhibition. Gelatin silver print.
Photograph courtesy of Marc Walter.

garments and accessories were refreshingly modern, and became the focus of the exhibition.

Poiret's creations were presented in three barges decorated by Dufy and the Atelier Martine. 'Amour' was dedicated to interior design, and 'Délices' was an elegant restaurant. 'Orgues' displayed fourteen wall hangings designed by Dufy, illustrating Poiret's latest collections.

An unprecedented event, the exhibition was attended by millions of European and American tourists, and by hundreds of international manufacturers. Its impact, not only on haute-couture but also on mainstream fashion, was immediate, and would still be felt throughout the coming decade.

95 LEFT
Jeanne Paquin, 'Chimère' evening gown. Beaded silk. French, 1925.
V&A: T.50-1948.

96 RIGHT
Cover of *Paris, arts décoratifs, 1925: Guide pratique du visiteur de Paris et de l'exposition*, Paris, 1925.
NAL.

1925

PARiS
ARTS DÉCORATiFS
1925

Guide de l'Exposition

LIBRAIRIE HACHETTE

FURTHER READING

Bouillon, Jean-Paul, *Art Déco, 1903–1940* (Geneva, 1989)

Damase, Jacques, *Sonia Delaunay: Fashion and Fabrics* (London, 1991)

Dars, Celestine, *A Fashion Parade: The Seeberger Collection* (London, 1977)

de la Haye, Amy and Shelley Tobin, *Chanel: The Couturière at Work* (London, 1994)

Demornex, Jacqueline, *Vionnet* (Paris, 1990)

Emmanuelle Toulet, *Le cinéma au rendez-vous des arts: France, années 20 et 30* (Paris, 1995)

Guillaume, Valérie, *Europe, 1910–1939: Quand l'art habillait le vêtement* (Paris, 1997)

Guilleminault, Gilbert et al, *Les années folles: le roman vrai de la 111e République* (Paris, 1956)

Harrison, Martin, *Shots of Style: Great Fashion Photographs Chosen by David Bailey* (exh. cat., Victoria and Albert Museum, London, 1985)

Hillier, Bevis, *The World of Art Deco* (exh. cat., Minneapolis Institute of Art, Minneapolis and London, 1971)

Howell, Georgina, *In Vogue: 60 years of fashion and celebrity from British Vogue* (London, 1978)

Japonisme et Mode (exh. cat., Palais Galliera, Paris, 1996)

Le dessin sous toutes ses coutures: croquis, illustrations, modèles 1760–1994 (exh. cat., Palais Galliera, Paris, 1995)

Les plus belles robes de la Cinémathèque française (exh. cat., Pavillon des Arts, Paris, 2001)

Paul Poiret et Nicole Groult: Maîtres de la Mode Art Déco (exh. cat., Palais Galliera, Paris, 1986)

Robinson, Julian, *The Golden Age of Style* (London, 1976)

Touches d'exotisme: 14e–20e siècles (exh. cat., Musée de la Mode et du Textile, Paris, 1998)

Vassiliev, Alexandre, *Beauty in Exile* (New York, 2000)

Völker, Angela, *Textiles of the Wiener Werkstätte 1910–1932* (London, 1990)

Worsley, Harriet, *The Hulton Getty Picture Collection: Decades of Fashion* (London, 2000)

Lydia Zaletova et al, *Costume Revolution: Textiles, Clothing and Costume of the Soviet Union in the Twenties* (exh. cat., Venice; English edn London, 1989)

INDEX
••••••••••••••••••••••••••••••••

Page numbers in italic refer to the illustration
captions on those pages.